Medieval Ornament
Ornement médiéval
Mittelalterlich Ornamente
Средневековые орнаменты

Clara Schmidt

L'Aventurine

Foreword

Having been disregarded for a long time, medieval art regained its nobility in the 19th century, thanks to artists like Viollet-le-Duc or writers like Prosper Mérimée, who contributed to the rescuing of buildings until then considered of no importance.

This renewed interest in medieval art resulted in numerous works presenting medieval ornamentation in the form of engravings. In this respect, Viollet-le-Duc's Dictionnaire raisonné de l'architecture française, Pugin's Gothic Ornament or James Kellaway Colling's Medieval Decorative Ornament are worth mentioning.

The ornamental collection we present in this book—foliage, animals, geometrical patterns—go through these works, in various fields: architecture, sculpture, fabrics, ivory…

Avant-propos

Longtemps méprisé, l'art médiéval regagna ses lettres de noblesse au XIX^e siècle, grâce entre autres à des artistes comme Viollet-le-Duc ou des écrivains comme Prosper Mérimée, qui contribuèrent au sauvetage d'édifices considérés jusqu'alors comme sans importance.

Ce regain d'intérêt aboutit à de nombreux ouvrages présentant l'ornement médiéval sous forme de gravures. On peut citer le *Dictionnaire raisonné de l'architecture française*, de Viollet-le-Duc, les gravures d'ornements gothiques de Pugin, ou le *Medieval Decorative Ornament* de James Kellaway Colling. Tous déclinent le répertoire ornemental que nous vous présentons ici – feuillages, animaux, décors géométriques – dans des domaines aussi divers que l'architecture, la sculpture, la reliure, les textiles, les ivoires…

Vorwort

Lange Zeit verachtet, so gewann das mittelalterliche Ornament im XIX Jahrhundert durch Künstler wie Viollet-le-Duc oder Schriftsteller wie Prosper Mérimée seine zentrale und grundlegende Bedeutung wieder zurück, deren Kunst Aufmerksamkeit auf Gebäude richtete, die sonst an Bedeutung verloren hätten. Dieses wiedergewonnene Interesse hat zahlreiche Werke, insbesondere Gravuren entstehen lassen, in welchen das mittelalterliche Ornament sich wiederfindet. Man kann an dieser Stelle das „Dictionnaire raisonné de l'architecture française " (Wörterbuch der französischen Architektur) von Viollet-le-Duc erwähnen oder Pugin' s Gotisches Ornament oder auch sein Mittelalterliche dekorative Ornament. Diese Künstler lehnten es zusammen ab, dieses hier präsentierte dekoratives Repertoire − Laub, Tiere, geometrische Formen- in die unterschiedlichen Gebiete der Architekturkunst, wie Skulpturen, Buchbinden, Textilien, Elfenbeinschnitzereien - in ihrer Kunst zu integrieren.

Предисловие

Средневековое искусство, забытое на протяжении долгого периода, снова приобрело популярность в 19-м веке, благодаря таким деятелям, как художник Виолле-ле-Дюк и писатель Проспер Мериме, которые внесли свой вклад в реставрацию зданий, до тех пор считавшихся никому не нужными.

Вновь проснувшийся интерес к средневековому искусству повлек за собой создание многочисленных работ с использованием средневековых орнаментов, наподобие тех, которые использовались при создании гравюр. Нельзя не отметить такие работы, как *Dictionnaire raisonné de l'architecture française* Виолле-ле-Дюка, Gothic Ornament Пьюджина и Medieval Decorative Ornament Джеймса Келлеуэя Коллинга. В данной книге представлена коллекция орнаментов — лиственных, с животными мотивами, геометрическими узорами — нашедших применение в различных сферах: архитектуре, скульптуре, текстиле, изделиях из слоновой кости...

• Illustrations •
• Illustrationen •
• Иллюстрации •

9

9; 11:
Italian marquetry, 15th century.
Marqueterie italienne, XVᵉ siècle.
Italienische Einlegearbeit des
XV. Jahrhunderts.
Итальянское маркетри, 15 век.

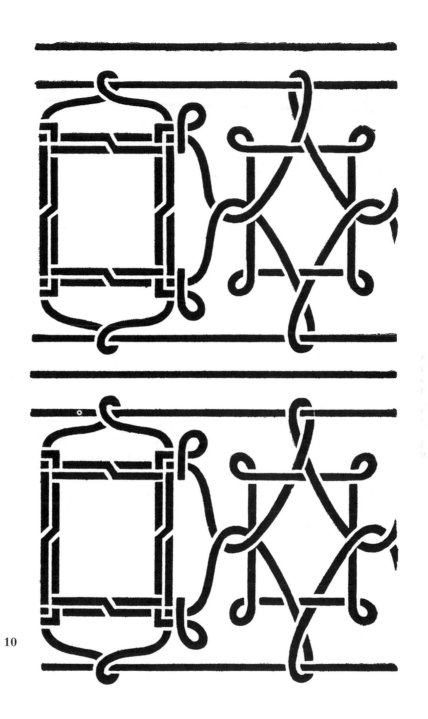

10

11-1

11-2

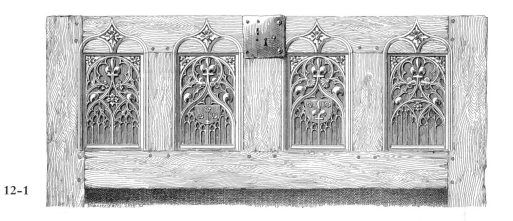

12-1

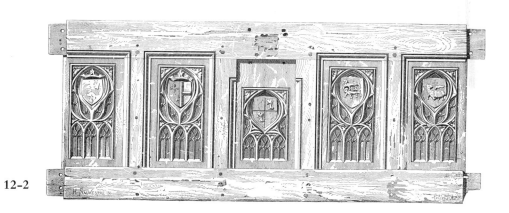

12-2

12; 13:
Sideboards, carved wood, France, 15th century.
Bahuts sculptés, France, XVᵉ siècle.
Truhen aus Holz mit eingearbeitetem Relief, Frankreich,
XV. Jahrhundert.
Буфеты, резьба по дереву, Франция, 15 век.

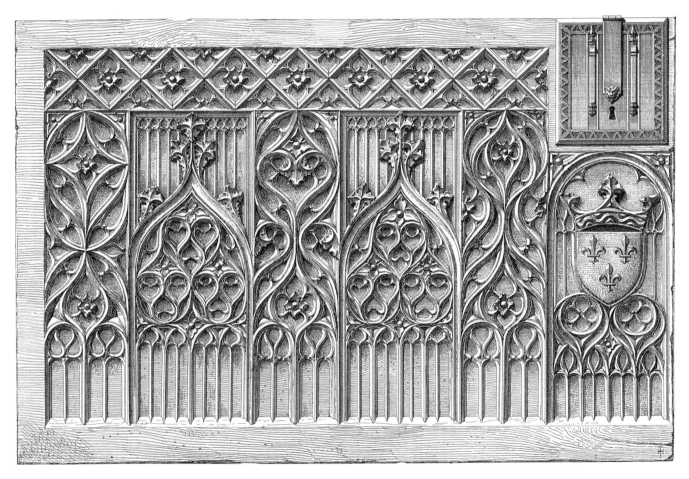

13

Panel, carved wood, France,
15th century.
Panneau en bois sculpté,
France, xvᵉ siècle.
Französische Schule.
Holzbrett mit
eingearbeitetem Relief,
XV. Jahrhundert.
Панель, резьба по дереву,
Франция, 15 век.

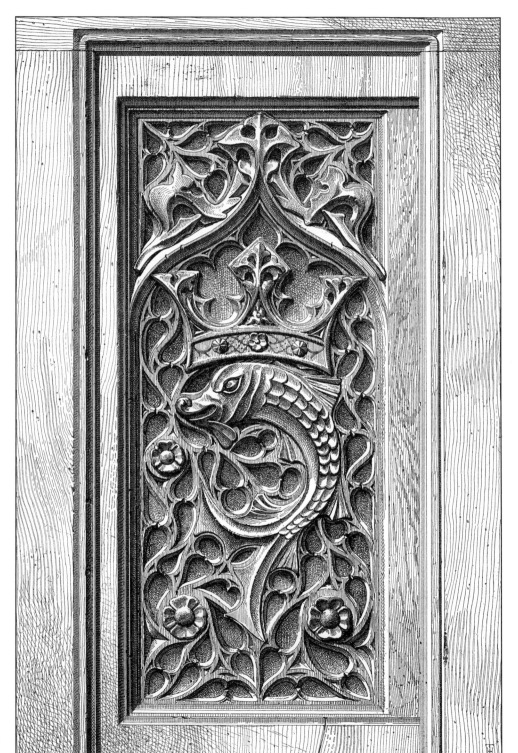

14

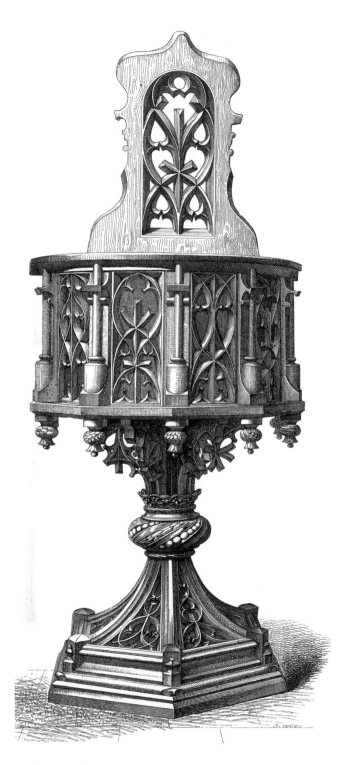

Semicircular seat, Germany,
15th century.
Siège semi-circulaire, Allemagne,
XVᵉ siècle.
Halbrunder Sitz, Deutschland,
XV. Jahrhundert.
Украшение полукруглого
сидения, Германия, 15 век.

15

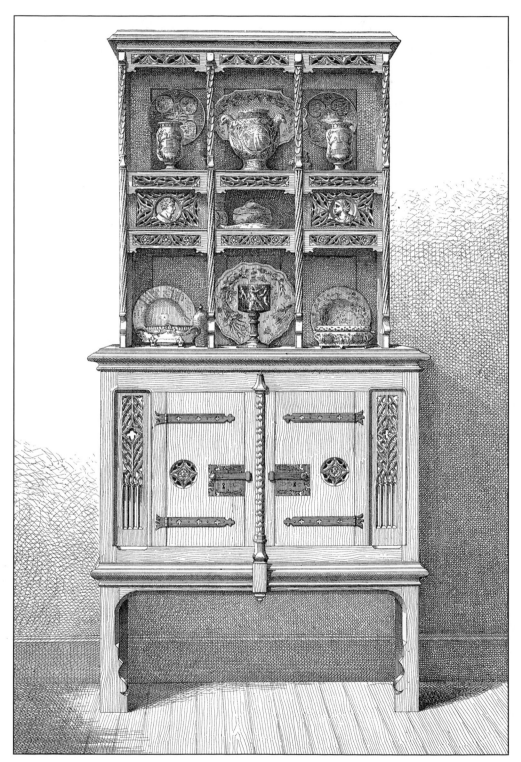

Sideboard, carved wood,
France, 15th century.
Dressoir en bois sculpté,
France, XVe siècle.
Anrichte aus Holz mit ein-
gearbeitetem Relief,
Frankreich, Champagne,
XV. Jahrhundert.
Буфет, резьба по дереву,
Франция, 15 век.

Credenza, carved wood, France, 15th century.
Crédence en bois sculpté, France, XVᵉ siècle.
Kredenz aus Holz mit eingearbeitetem Relief, Frankreich, XV. Jahrhundert.
Низкий горизонтальный шкаф, украшенный резьбой по дереву, Франция, 15 век.

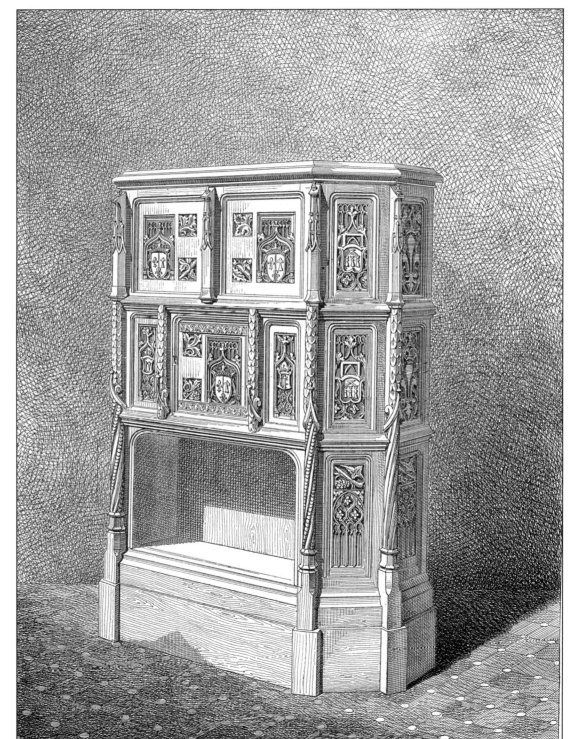

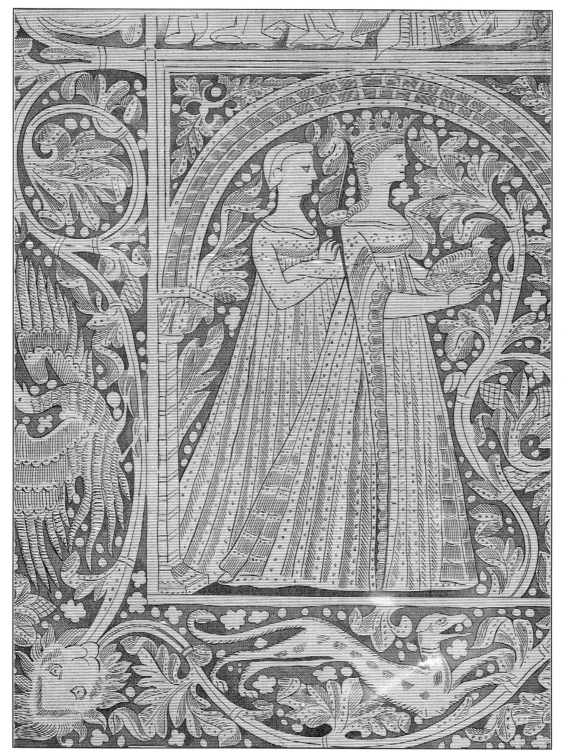

Chest, carved wood,
Italy, 14th century.
Coffre en bois gravé,
Italie, XIVᵉ siècle.
Koffer aus Holz mit
Gravur, Italien,
XIV. Jahrhundert.
Сундук, резьба по
дереву, Италия,
14 век.

18

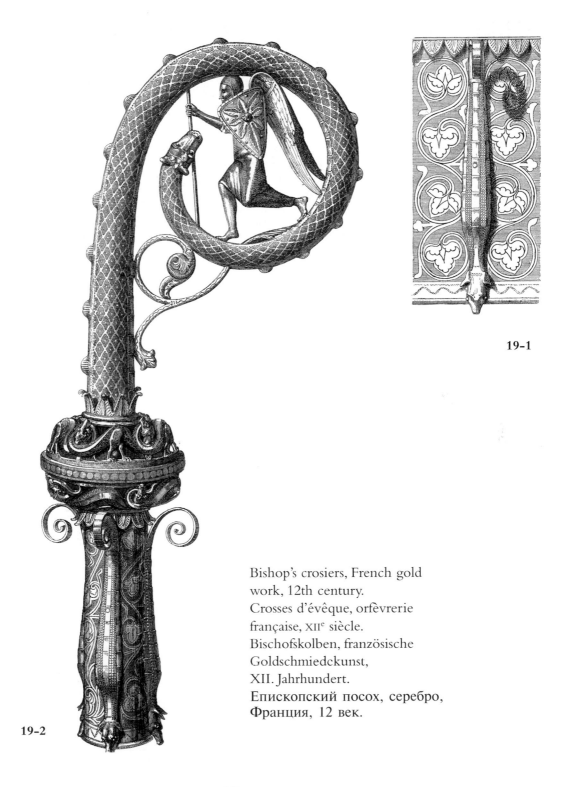

19-1

19-2

Bishop's crosiers, French gold
work, 12th century.
Crosses d'évêque, orfèvrerie
française, XIIᵉ siècle.
Bischofskolben, französische
Goldschmiedckunst,
XII. Jahrhundert.
Епископский посох, серебро,
Франция, 12 век.

20-1

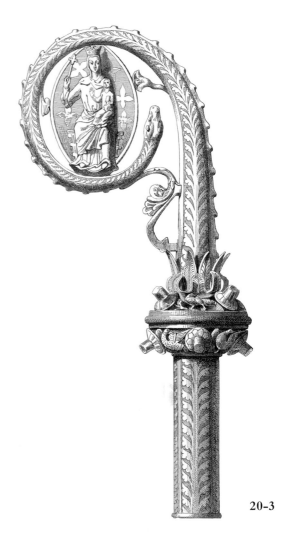

20-3

20-1; 20-2; 21-1; 21-3:
Bishop's crosiers, engraved copper, France, 13th century.
Crosses d'évêque en cuivre ciselé, France, XIII^e siècle.
Bischofskolben aus Kupfer mit Gravierungen, Frankreichs, XIII. Jahrhundert.
Епископские посохи, гравюра на меди, Франция, 13 век.

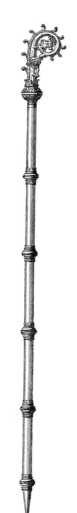

20-2

20-3:
Bishop's crosier, French gold work, 12th century.
Crosse d'évêque, orfèvrerie française, XII^e siècle.
Bischofskolben, französische Goldschmiedekunst, XII. Jahrhundert.
Епископский посох, серебро, Франция, 12 век.

20

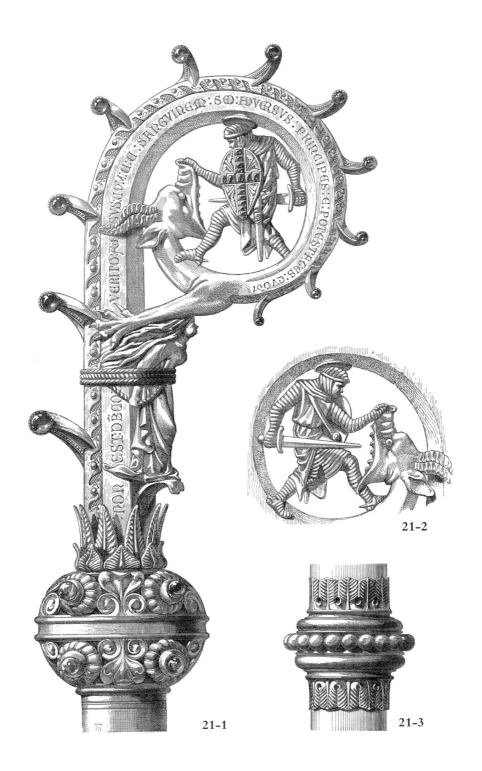

21-1

21-2

21-3

Bishop's crosier, enameled copper, France, 13th century.
Crosse d'évêque en cuivre émaillé, Limoges, XIIIᵉ siècle.
Kolben aus emailliertem Kupfer, Limoges, XIII. Jahrhundert.
Епископский посох, эмалированная медь, Лимож, 13 век.

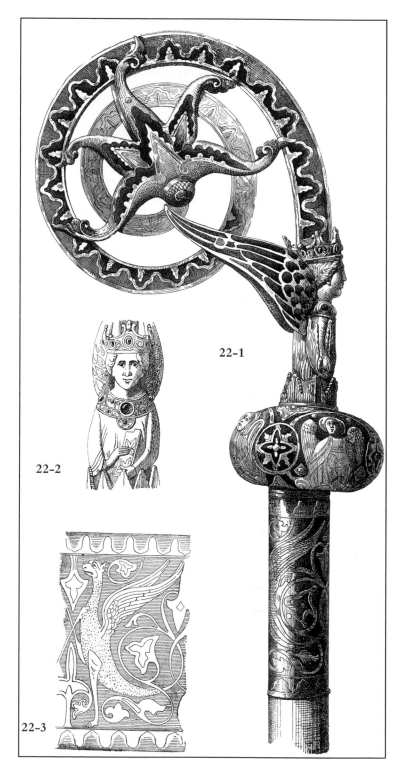

22-1

22-2

22-3

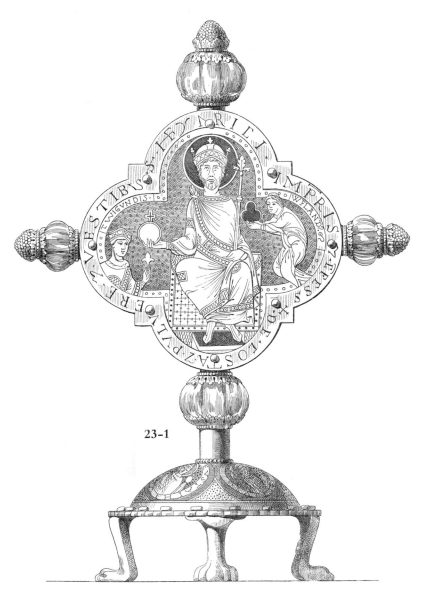

23-1

23-2

Emperor's Henry reliquary, Germany,
12th century.
Reliquaire de l'empereur Henri,
Allemagne, XIIᵉ siècle.
Reliquienschrein des Kaisers Heinrich,
Deutschland, XII. Jahrhundert.
Усыпальница короля Генриха,
Германия, 12 век.

23-3 23-4 23-5

24:
Censers, smelted and engraved copper, France, 12th century.
Encensoirs en cuivre fondu et gravé, France, XIIᵉ siècle.
Weihrauchgefäße aus geschmolzenem Kupfer mit Prägungen, Frankreich, XII. Jahrhundert.
Кадила, медное плавление, гравюра на меди, Франция, 12 век.

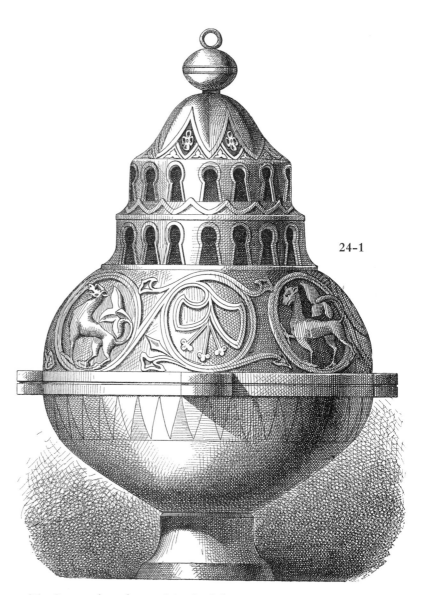

24-1

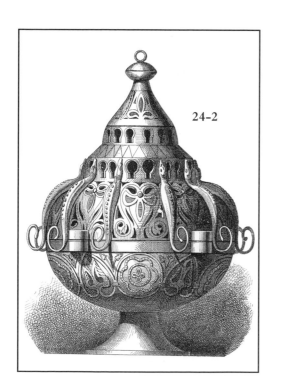

24-2

25: Censer, based on a Martin Schongauer engraving, Germany, 15th century.
Encensoir d'après une gravure de Martin Schoengauer, Allemagne, XVᵉ siècle.
Nebenstehend: Weihrauchgefäß gemäß einer Gravur von Martin Schoengauer, Deutschland, XV. Jahrhundert.
На противоположной стороне: Кадило, созданное под влиянием гравюр Мартина Шонгауэра, Германия, 15 век.

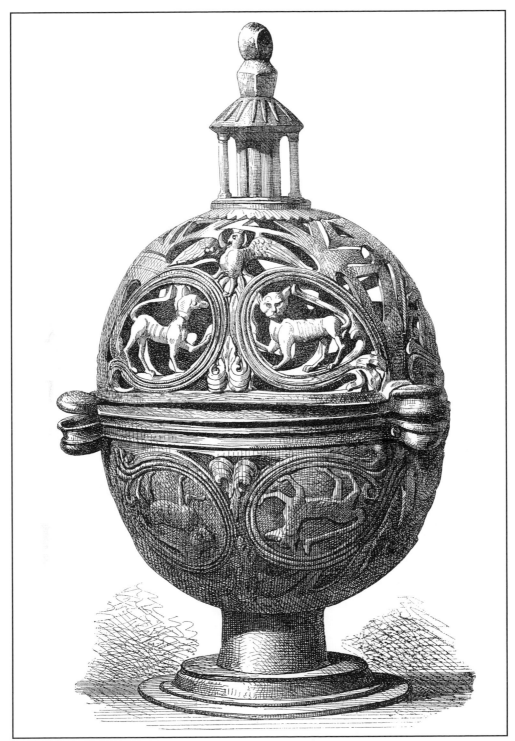

26; 27:
Censers, copper and
bronze, French gold
work, 12th century.
Encensoirs en cuivre et
bronze, orfèvrerie
française, XIIᵉ siècle.
Weihrauchgefäße aus
Kupfer und Bronze,
französischer
Goldschmiedekunst
XII. Jahrhundert.
Кадила из меди и
бронзы, серебро,
Франция, 12 век.

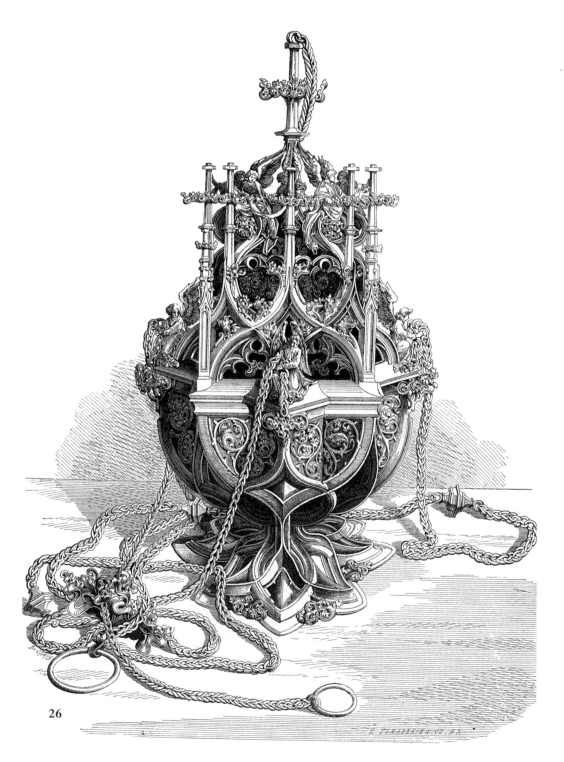

26

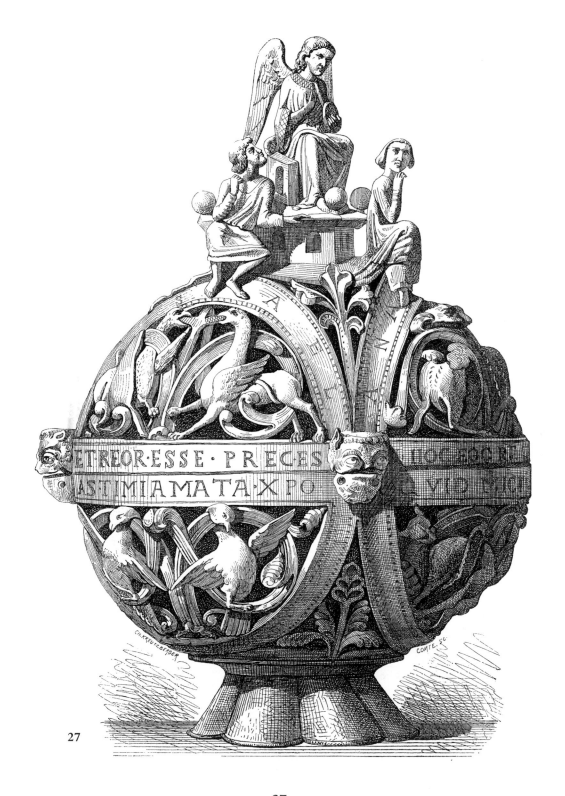

27

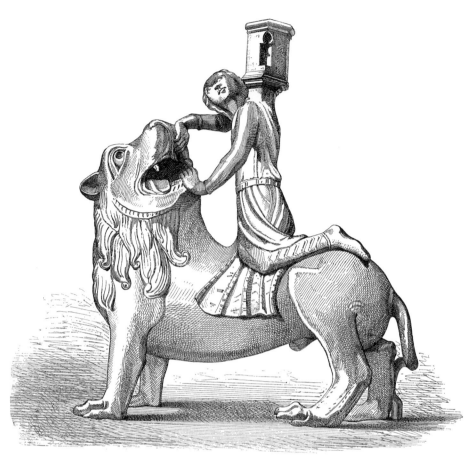

28-1

28-1:
Candlestick, bronze, France,
12th century.
Chandelier en bronze, France,
XIIᵉ siècle.
Kerzenständer aus Bronze,
Frankreich, XII. Jahrhundert.
Подсвечник, бронза, Франция,
12 век.

28-2:
Candlestick, bronze, Germany, 12th century.
Chandelier en bronze, Allemagne, XIIᵉ siècle.
Fackel aus Bronze, Deutschland, XII. Jahrhundert.
Подсвечник из бронзы, Германия, 12 век.

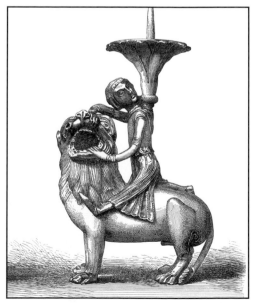

28-2

Candlestick, bronze,
Germany,
12th century.
Chandelier en
bronze, Allemagne,
XIIᵉ siècle.
Fackel aus Bronze,
Deutschland,
XII. Jahrhundert.
Подсвечник из
бронзы, Германия,
12 век.

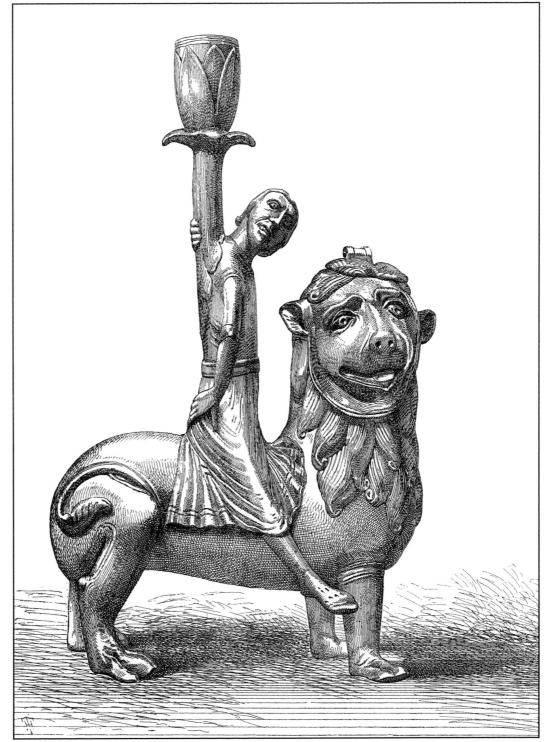

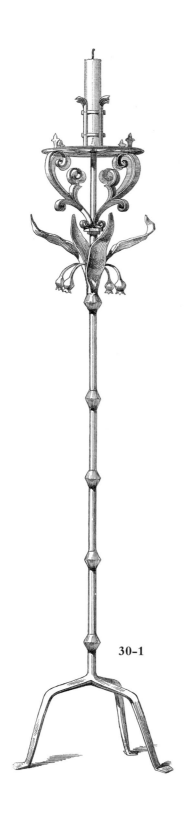

30-1

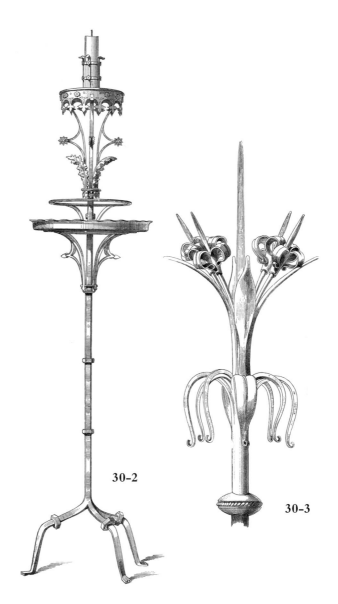

30-2

30-3

Candelabras, Saint Peter's church of Tarrosa, Spain, 14th century.
Candélabres de l'église de Saint-Pierre de Tarrosa, Espagne, XIVᵉ siècle.
Kandelaber der Kirche Saint-Pierre von Tarrosa, Spanien,
XIV. Jahrhundert.
Канделябры, церковь св. Петра в Тарросе, Испания, 14 век.

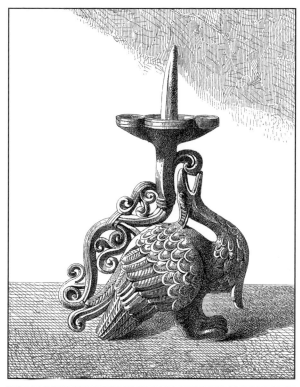

31-1

21; 32:
Candlesticks, bronze, Germany,
12th century.
Chandeliers en bronze, Allemagne,
XII^e siècle.
Kerzenständer aus Bronze,
Deutschland, XII. Jahrhundert.
Подсвечники из бронзы,
Германия, 12 век.

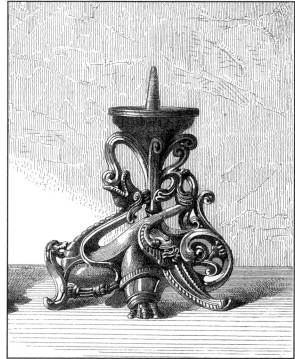

31-2

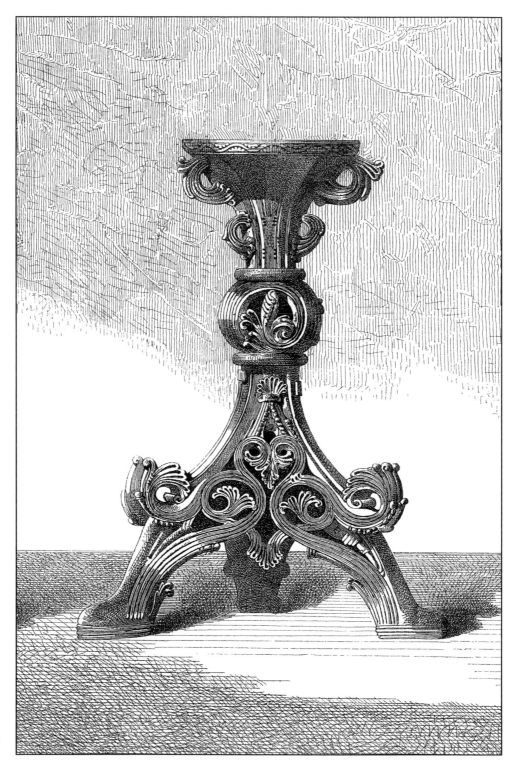

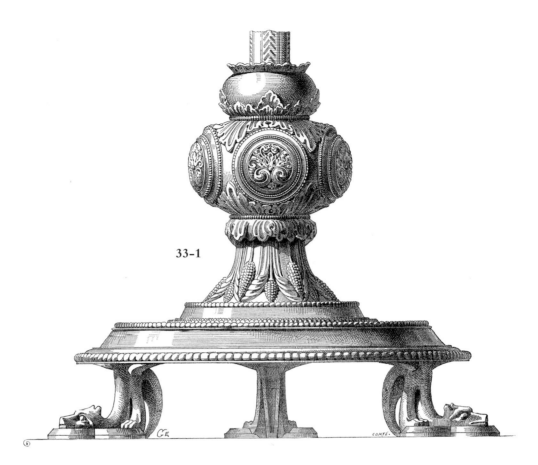

33-1

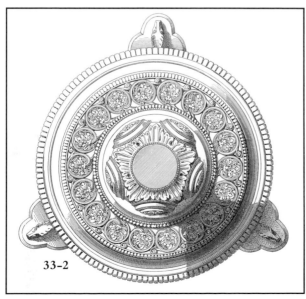

33-2

Base of a candlestick, bronze,
France, 12th century.
Pied d'un chandelier en bronze,
France, XIIᵉ siècle.
Fuß eines Kerzenständers aus
Bronze, Frankreich,
XII. Jahrhundert.
Подставка для подсвечника,
бронза, Франция, 12 век.

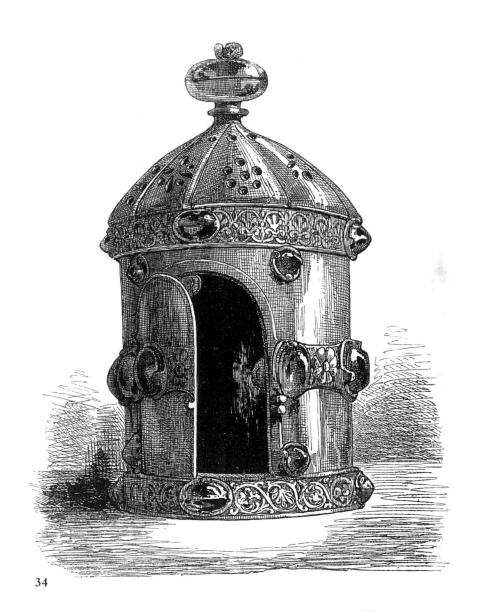

34

35-1

35-2

35-3

34; 35:

Lantern, repoussé bronze, France, 12th century.
Lanterne en bronze repoussé, France, XIIᵉ siècle.
Laterne aus Bronze mit heraus gearbeiteten
Ornamenten, Frankreich, XII. Jahrhundert.
Фонарь, чеканка, бронза, Франция, 12 век.

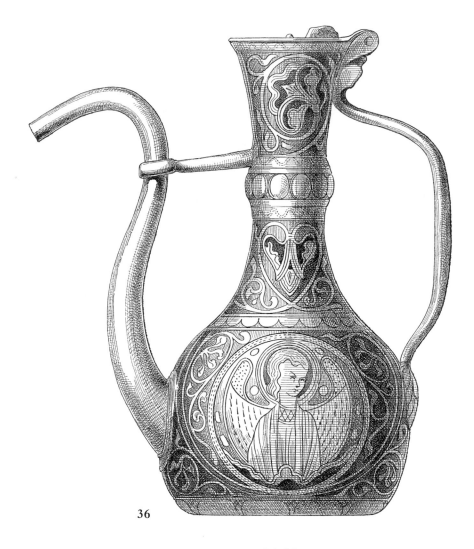

36

36–38:
Cruets, enameled copper, France, 13th century.
Burette en cuivre émaillé, France, XIIIe siècle.
Trinkgefäss aus emailliertem Kupfer, französische Goldschmiedekunst
XIII. Jahrhundert.
Графин, эмаль, медь, Франция, 13 век.

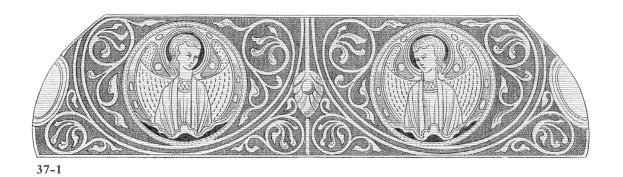

37-1

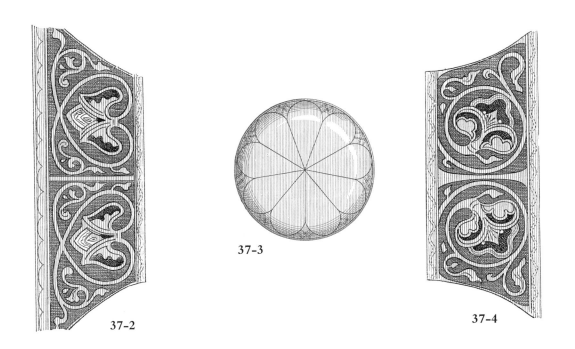

37-2

37-3

37-4

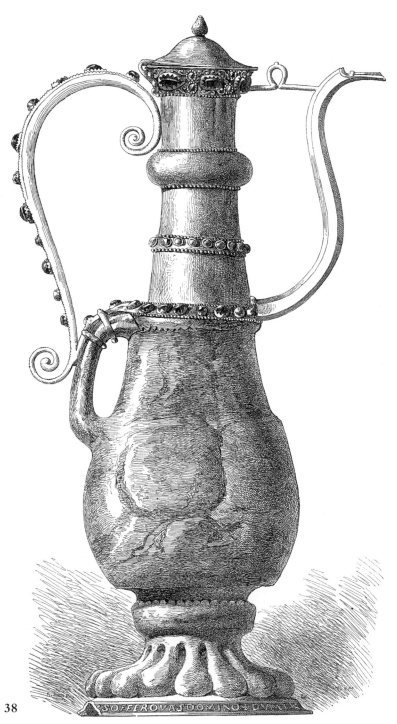

38

Casket, gilded bronze,
Scandinavia,
9th century.
Coffret en bronze doré,
Scandinavie,
IXᵉ siècle.
Kästchen aus Bronze,
vergoldet, Skandinavien,
IX Jahrhundert.
Гроб из позолоченной
бронзы, Скандинавия,
9 век.

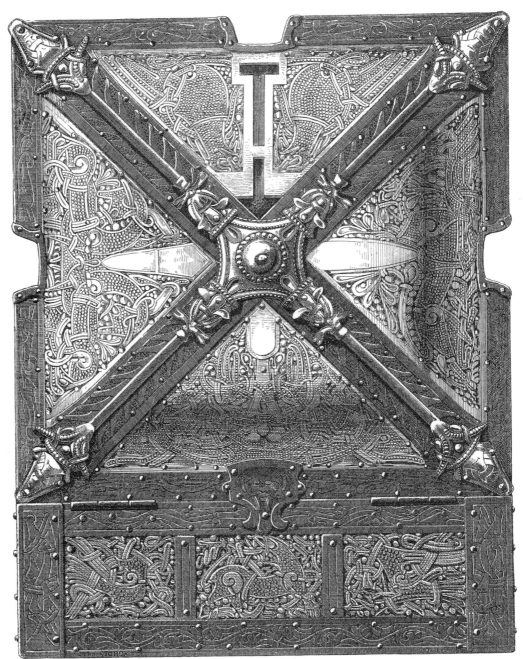

39

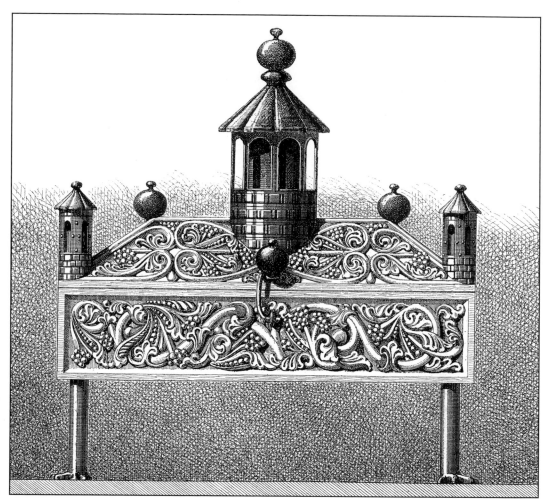

40-1

Reliquary, ivory and copper, Germany,
12th century.
Reliquaire en ivoire et en cuivre,
Allemagne, XII^e siècle.
Reliquienschrein aus Elfenbein und
Kupfer, Deutschland, XII. Jahrhundert.
Усыпальница из слоновой кости и
меди, Германия, 12 век.

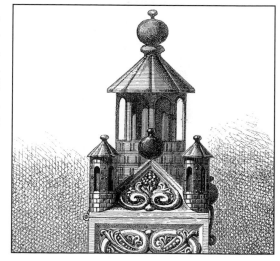

40-2

40

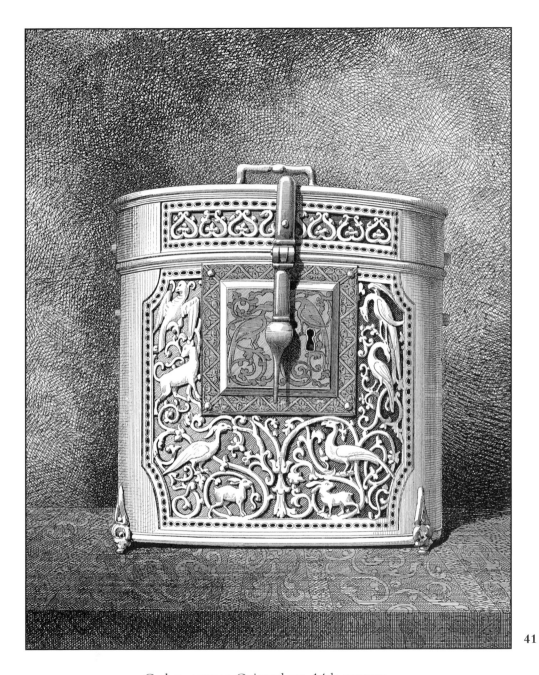

Casket, copper, Oriental art, 14th century.
Coffret en cuivre, art oriental, XIV^e siècle.
Kleine Kupfertruhe, orientalische Kunst, XIV. Jahrhundert
Гроб из меди, Восточное искусство, 14 век.

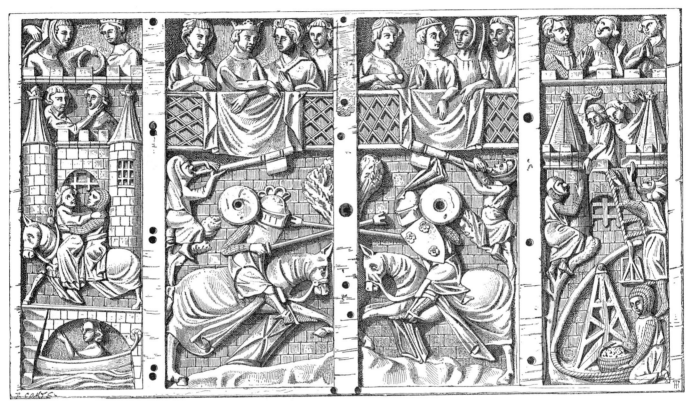

42

Front of a casket, ivory, France, 14th century.
Face d'un coffret en ivoire, France, XIV^e siècle.
Seite eines Kästchens aus Elfenbein, Frankreich, XIV. Jahrhundert.
Передняя часть гроба, слоновая кость, Франция, 14 век.

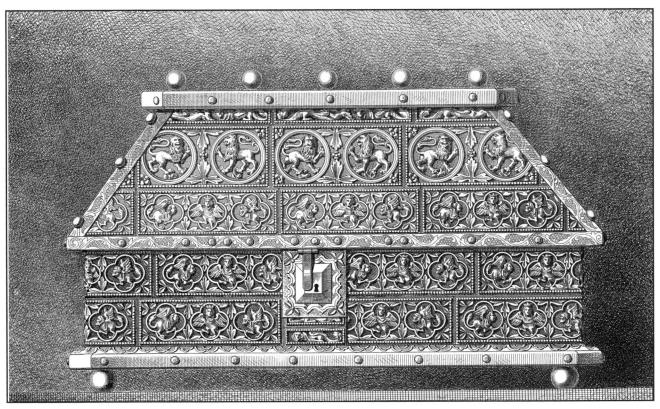

Wedding casket, engraved copper, Venice, 14th century.
Coffret de mariage en cuivre estampé, Venise, XIVe siècle.
Kleiner Koffer für Hochzeiten aus geprägtem Kupfer, Venedig, XIV. Jahrhundert.
Свадебный ларец, гравюра на меди, Венеция, 14 век.

44; 45:
Reliquary decoration, France,
14th century.
Décoration d'un reliquaire, France,
XIVe siècle.
Dekoration einer Reliquie,
Frankreich, XIV. Jahrhundert.
Украшение усыпальницы,
Франция, 14 век.

44–1

44–2

45-1

45-2

45-3

45

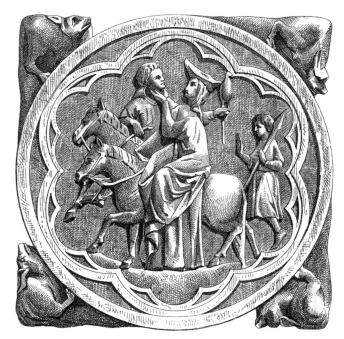

46-1

Mirrors frames, ivory, France,
14th century.
Cadres de miroirs en ivoire, France,
XIVe siècle.
Elfenbeinrahmen für Spiegel,
Frankreich, XIV. Jahrhundert.
Рамки для зеркал из слоновой
кости, Франция, 14 век.

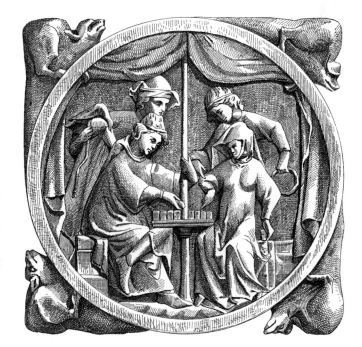

46-2

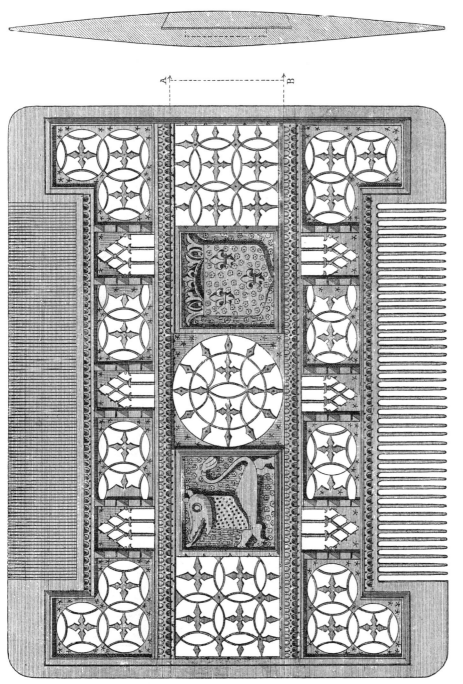

Wedding's comb, carved
wood, France,
15th century.
Peigne de mariage en bois
découpé, France,
XVe siècle.
Holzkamm für
Hochzeitsfrisuren,
Frankreichs,
XV. Jahrhundert.
Свадебный гребень,
резьба по дереву,
Франция, 15 век.

47

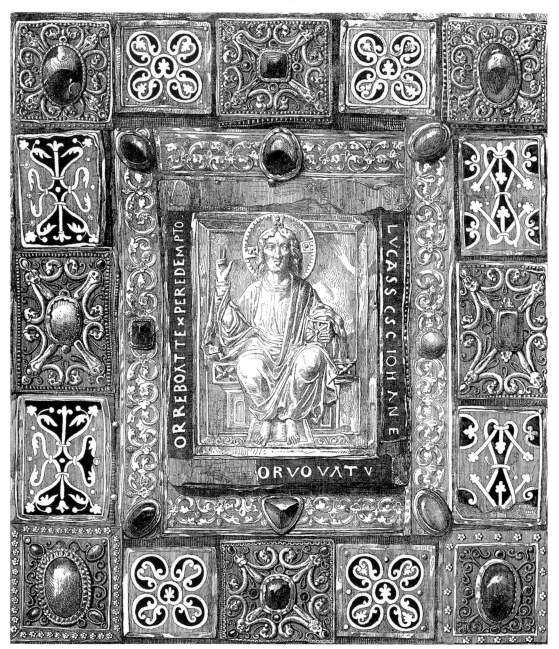

Manuscript's binding,
Byzantine gold work,
12th century.
Reliure de manuscrit,
orfèvrerie byzantine,
XIIᵉ siècle.
Manuskripteinbindung,
byzantinische
Goldschmiedekunst
XII Jahrhundert.
Обрамление
манускрипта,
византийские
ювелирные
украшения, 12 век.

48

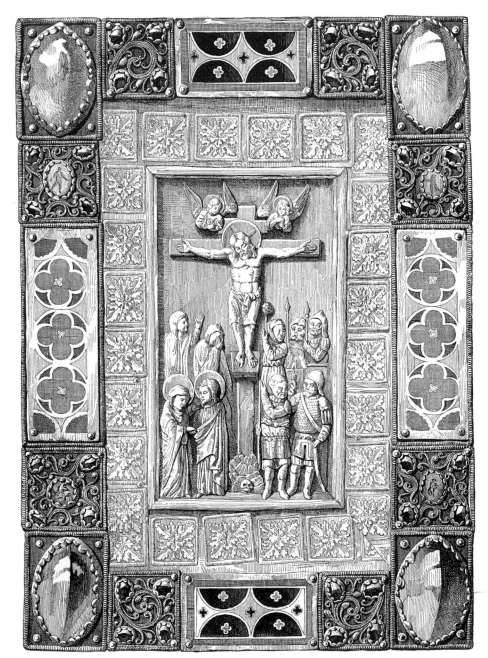

Manuscript's binding, gold work,
coloured enamels, ivory,
13th century.
Reliure de manuscrit. Orfèvrerie,
émaux, ivoires, XIIIᵉ siècle.
Manuskripteinbindung.
Goldschmiedekunst, emailliertes
Elfenbein, XIII. Jahrhundert.
Обрамление манускрипта,
ювелирные украшения,
цветная эмаль, слоновая
кость, 13 век.

49

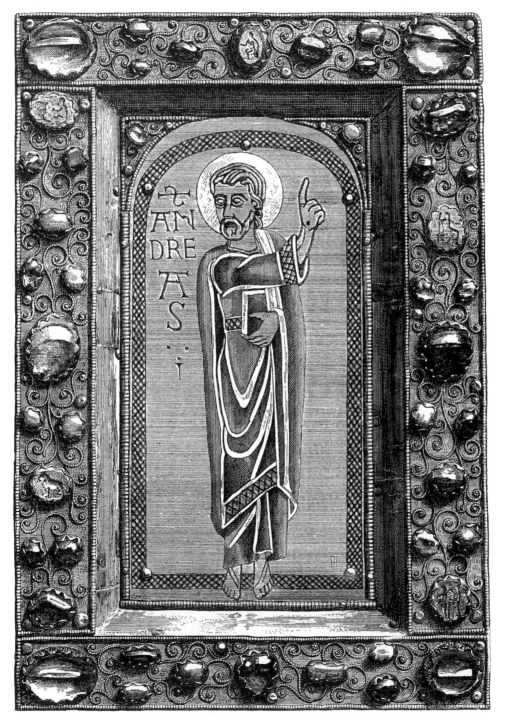

Enameled binding,
France, 12th century.
Reliure émaillée, France,
XIIᵉ siècle.
Emaillierter
Bucheinband, Frankreich,
XII. Jahrhundert.
Покрытый глазурью
переплет, Франция,
12 век.

51-1

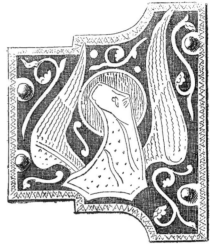

51-2

Ornaments on a cross,
copper, France,
12th century.
Ornements de croix
stationnaire en cuivre,
France, XIIe siècle.
Verzierungen eines
stehenden Kreuzes aus
Kupfer, Limoges,
XII. Jahrhundert.
Орнаменты для
креста из меди,
Франция, 12 век.

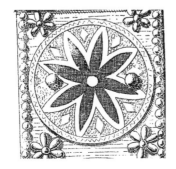

51-3

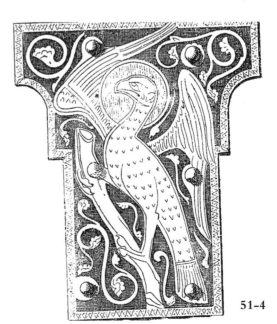

51-4

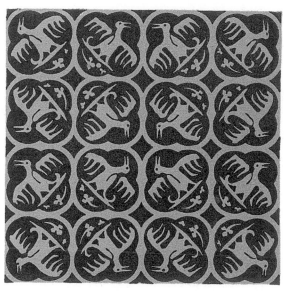

52-1

52-2

52, 53:
Tiles, enameled earthenware,
France, 13th century.
Carrelage en terre cuite
émaillée, France, XIII^e siècle.
Emaillierte Tonfließen,
Frankreich, XIII. Jahrhundert.
Изразцы из покрытого
эмалью фаянса, Франция,
13 век.

53-1

53-2

53-3

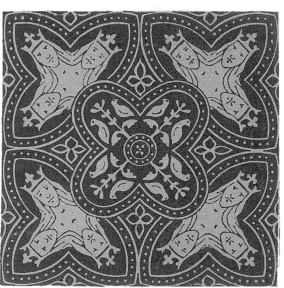

53-4

54-1

54-2

54-3

54-4

Keystones, England.
Clefs de voûtes, Angleterre.
Schlussstücke aus Holz zur Befestigung zwischen Dach und Gebäude.
Замковые камни, Англия.

Painted Ceiling, Peterborough Cathedral.
Plafond peint, cathédrale de Peterborough.
Deckenmalerei, Kathedrale, St. Petersburg.
Разрисованный потолок, Собор в Питерборо.

56

56; 57:
Painted Ceiling, Norwich Cathedral.
Plafond peint, Cathédrale de Norwich.
Deckenmalerei, Kathedrale in Norwich
Разрисованный потолок, Собор в Норидже.

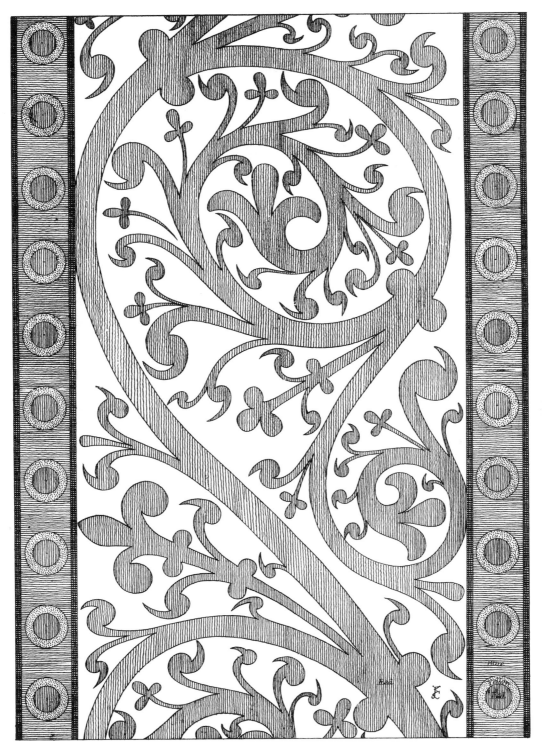

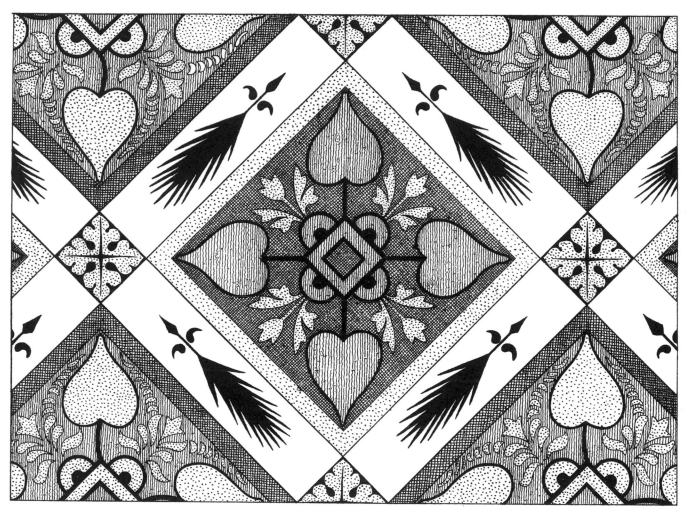

58-61:
Painted Diapers, Tewkesbury Abbey Church.
Damassés peints, église de l'abbaye de Tewkesbury.
Bemalter Stoff , Abtei-Kirche in Tewkesbury
Разрисованное полотно, церковь при аббатстве в Тьюксбери.

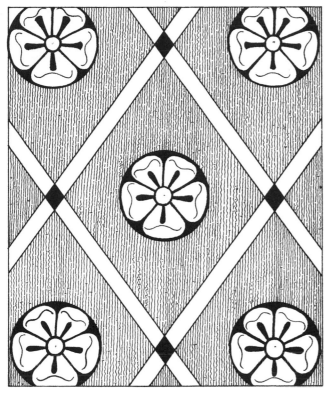

59-1

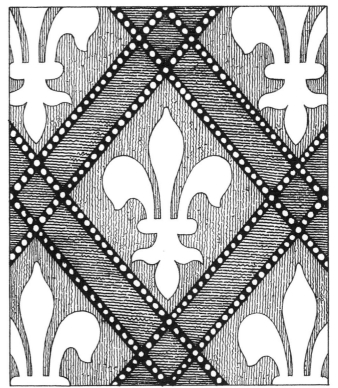

59-2

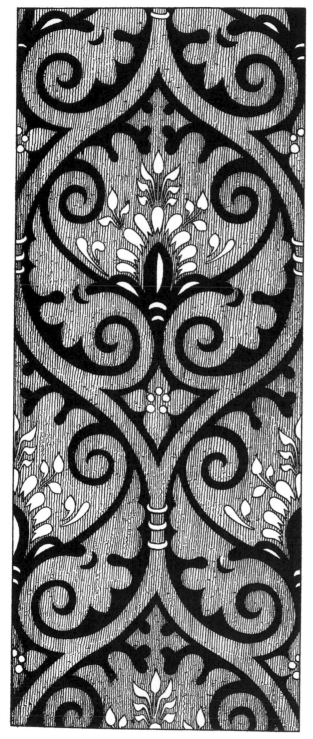

60-1

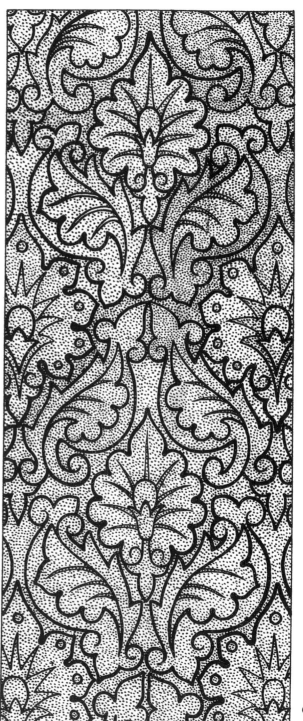

60-2

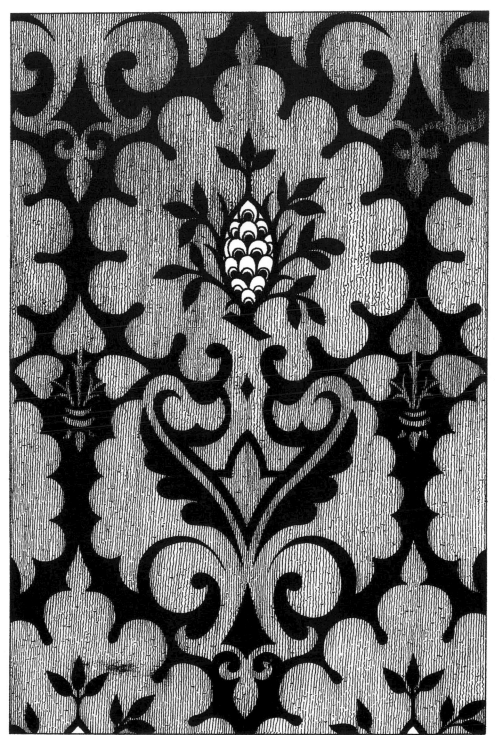

61

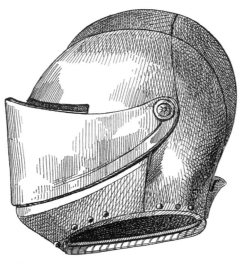

62-1

62; 63:
Helmets, 14th and 15th centuries.
Casques d'armures, XIV^e et XV^e siècles.
Rüstungshelme, XIV. und
XV. Jahrhundert.
Шлемы, 14 и 15 века.

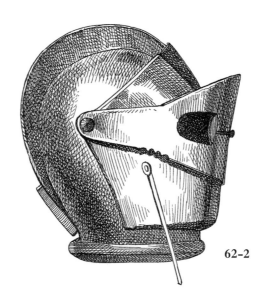

62-2

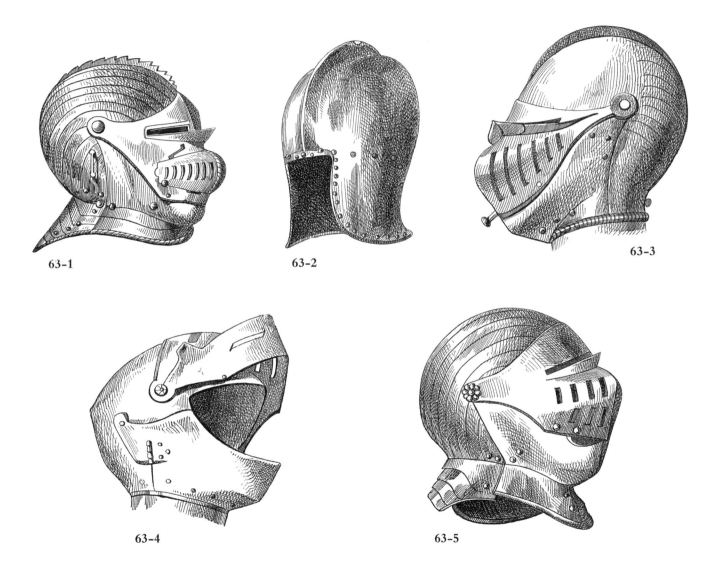

63-1

63-2

63-3

63-4

63-5

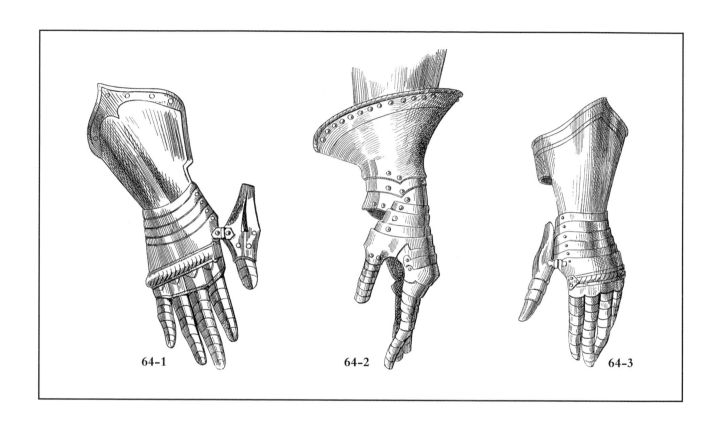

64-1 64-2 64-3

64; 65:

Gauntlets, France, 15th century.

Gantelets d'armures, France, XV^e siècle.

Handschuh, zu Rüstungen gehörend, Frankreich, XV. Jahrhundert.

Латные рукавицы, Франция, 15 век.

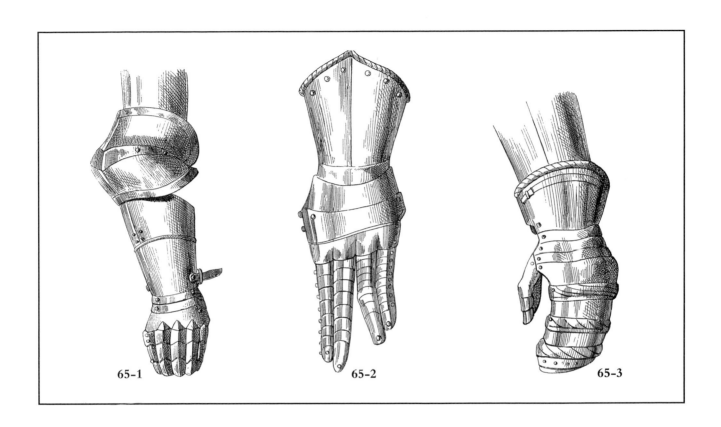

65-1 65-2 65-3

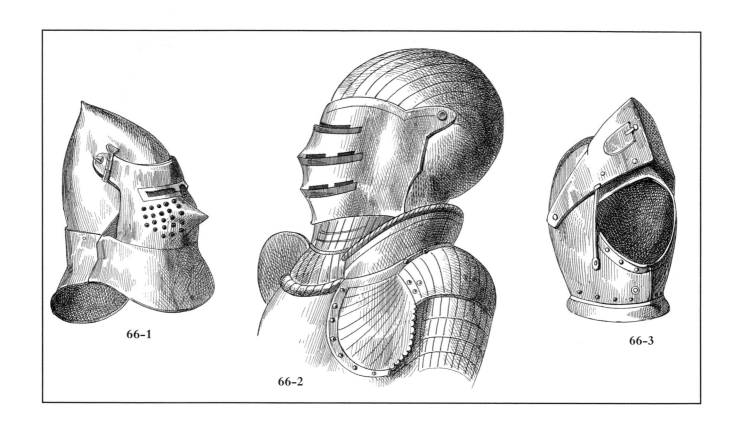

66-1

66-2

66-3

66; 67:
Helmets, France, 12th and 14th centuries.
Heaumes d'armures, France, XII^e et XIV^e siècles.
Helme französischer Rüstungen, XII. und XIV. Jahrhundert.
Шлемы, Франция, 12 и 14 века.

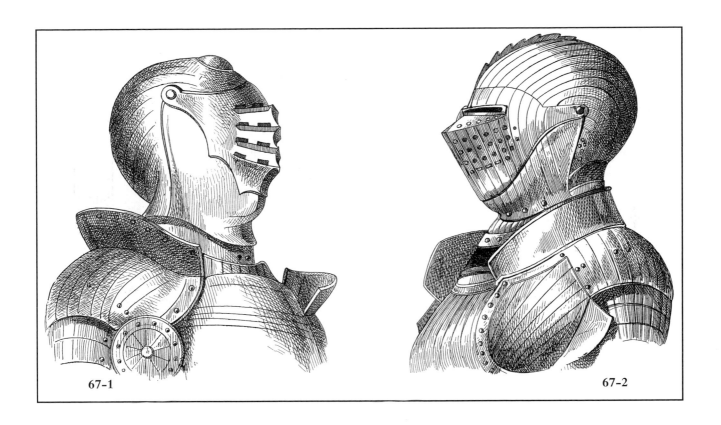

67-1

67-2

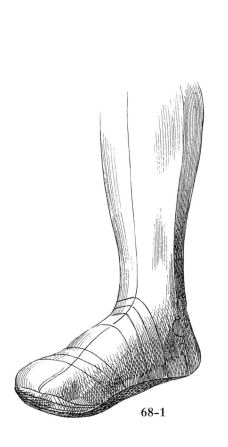

68-1

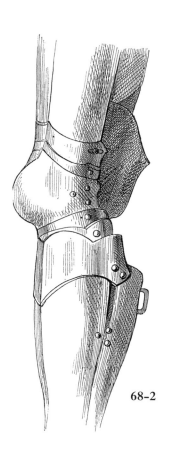

68-2

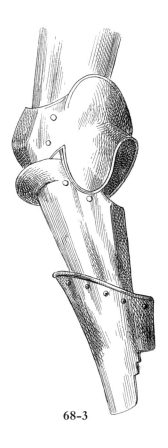

68-3

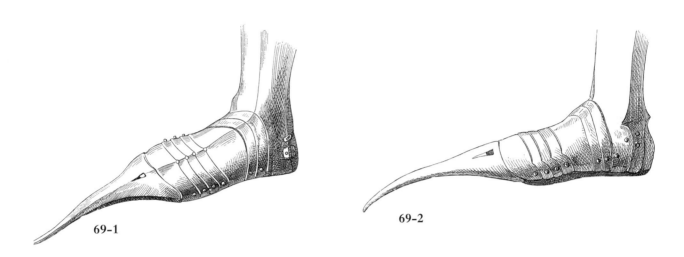

69-1

69-2

68; 69:
Armbands and cuisses, France, 12th and 14th centuries.
Brassards et cuissards d'armures, France, XII^e et XIV^e siècles.
Fuß- und Gelenkschutz französischer Rüstungen, XII. und XIV. Jahrhundert.
Нарукавные повязки и набедренники, Франция, 12 и 14 века.

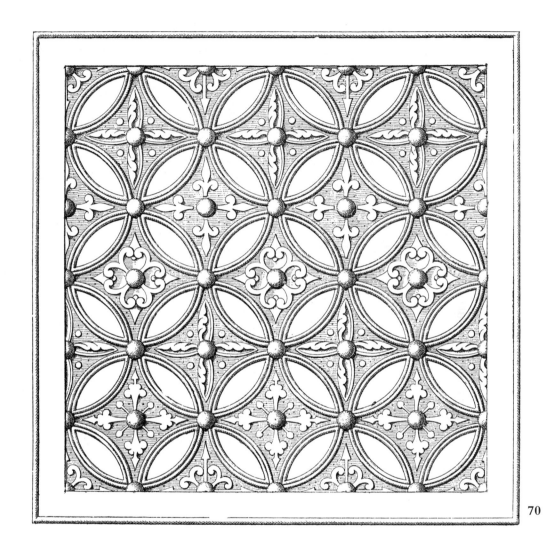

70

70; 71:
Sacerdotal garment finery, France, 13th century.
Parures de vêtements sacerdotaux, France, XIII^e siècle.
Priesterlicher Kleidung, mit Symbolen und Verzierungen geschmückt, Domschatz der Kathedrale in Sens, Frankreich, XIII. Jahrhundert.
Украшение церковного одеяния, Франция, 13 век.

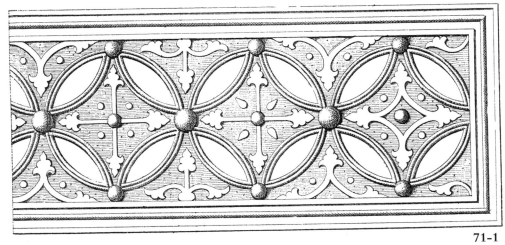

71-1

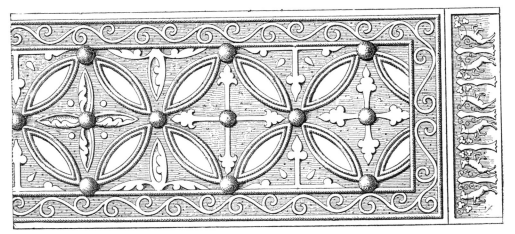

71-2

72-1

72-2

72-3

72-4

72-74:
Clasps, bronze, 12th and 13th centuries.
Agrafes de bronze, XII^e et XIII^e siècles.
Bronzespangen, XII. und XIII. Jahrhundert.
Бронзовые пряжки, 12 и 13 века.

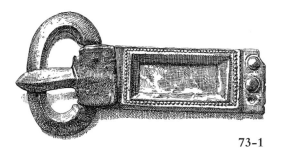

73-1

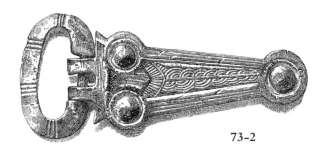

73-2

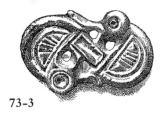

73-3

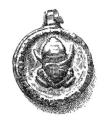

73-4

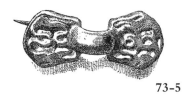

73-5

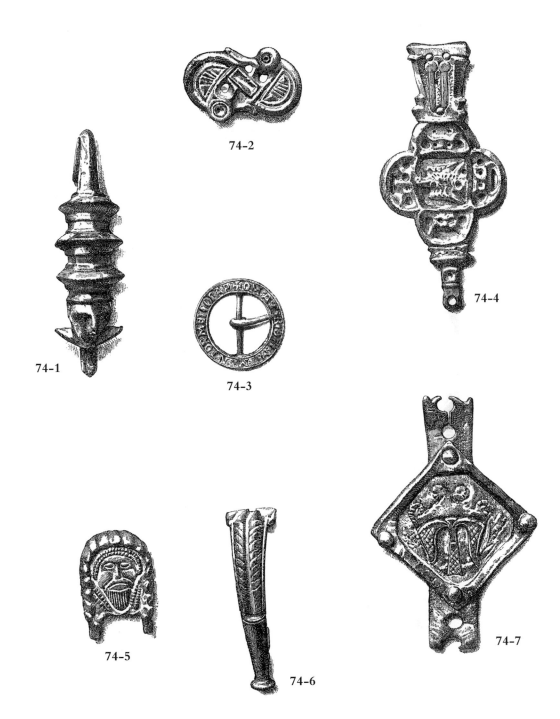

74-2

74-4

74-1

74-3

74-5

74-6

74-7

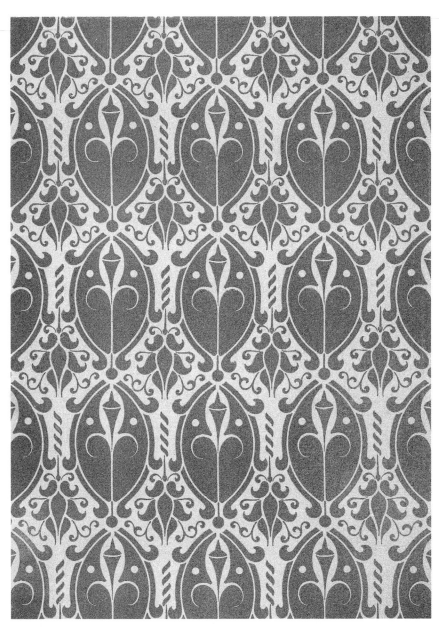

75

Two tones fabric, Italy, 15th century.
Tissu à deux tons, Italie, xvᵉ siècle.
Stoff aus zwei verschiedenen Farben, Italien, XV. Jahrhundert.
Двухтонная ткань, Италия, 15 век.

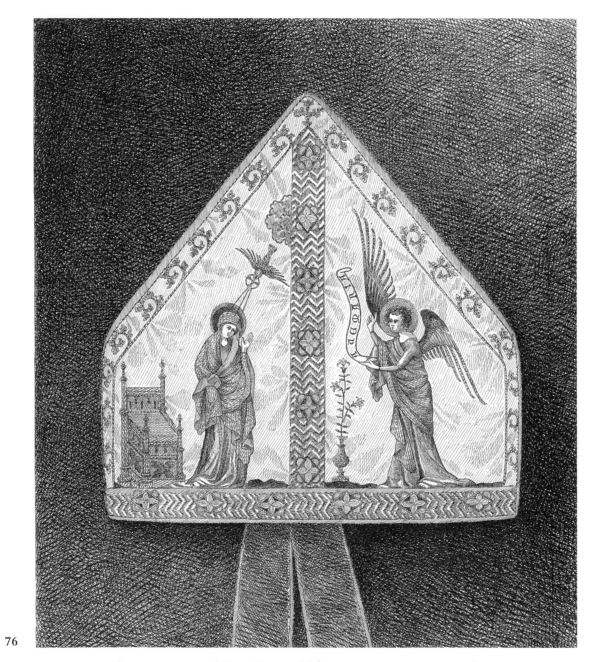

Mitre, France, 14th century.
Mitre, France, XIV^e siècle.
Mitra des Bischof's zu Genf, Frankreich, XIV. Jahrhundert.
Митра, Франция, 14 век.

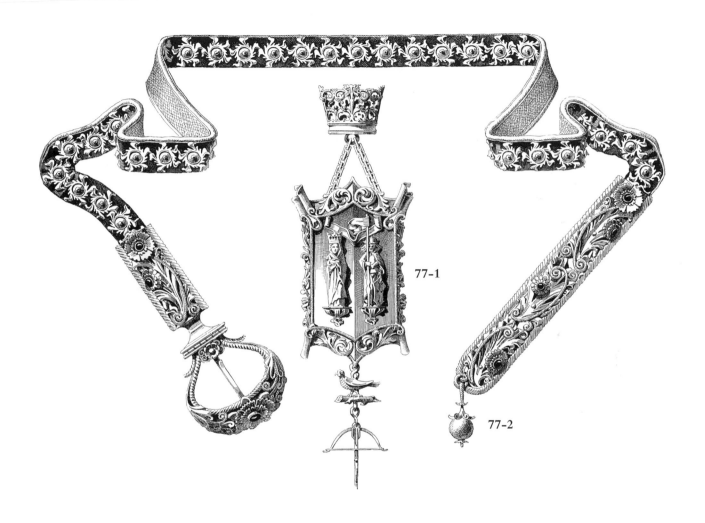

77-1

77-2

Belt, engraved and gilded silver, France, 14th century.
Ceinture en argent ciselé et doré, France, XIVᵉ siècle.
Gurt mit Silberschnitzereien und vergoldet, Frankreich, XIV. Jahrhundert.
Пояс, гравировка, позолоченное серебро, Франция, 14 век.

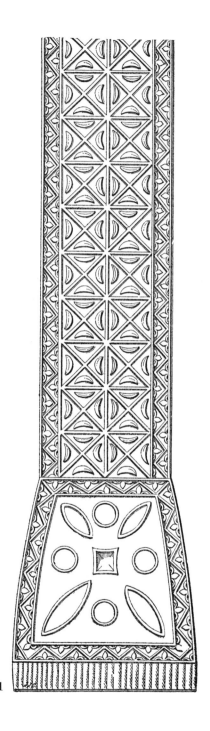

78-1

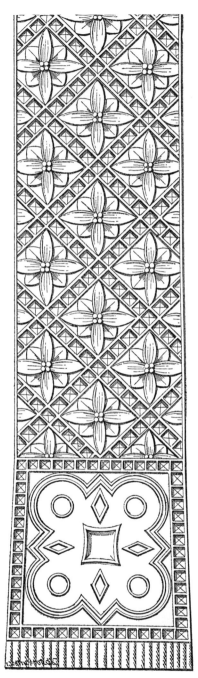

78-2

78; 79:
Sacerdotal
garment, maniples,
France,
13th century.
Vêtements
sacerdotaux,
manipules, France,
XIIIᵉ siècle.
Priesterliche
Kleidung,
Frankreich,
XIII. Jahrhundert.
Священническое
одеяние,
манипула,
Франция, 13 век.

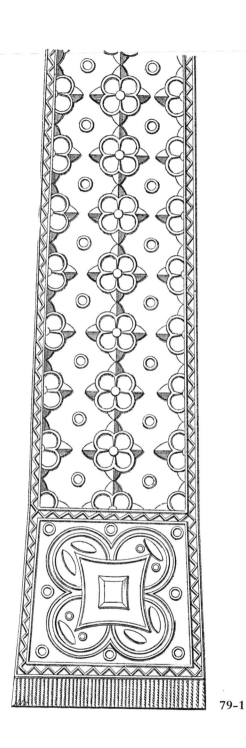

79-1

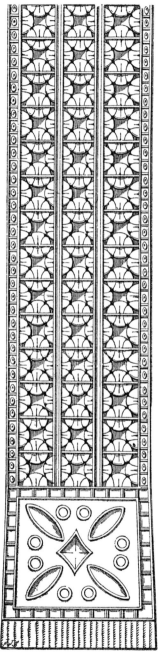

79-2

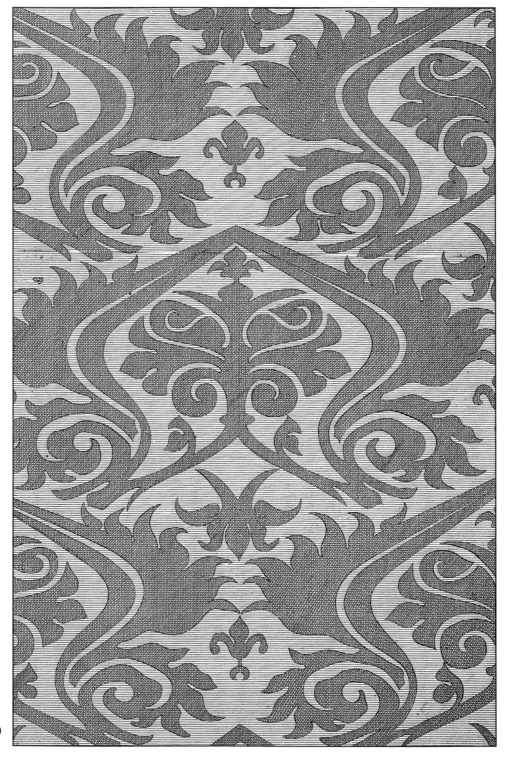

Damask, silk, Italy,
14th century.
Damas de soie, Italie,
XIVᵉ siècle.
Seidenstoff, Italien,
XIV. Jahrhundert.
**Шелковый дамаск,
Италия, 14 век.**

80

Damask, silk, Spain,
14th century.
Damas de soie, Espagne,
XIV^e siècle.
Seidenstoff, Spanien,
XIV. Jahrhundert.
**Шелковый дамаск,
Испания, 14 век.**

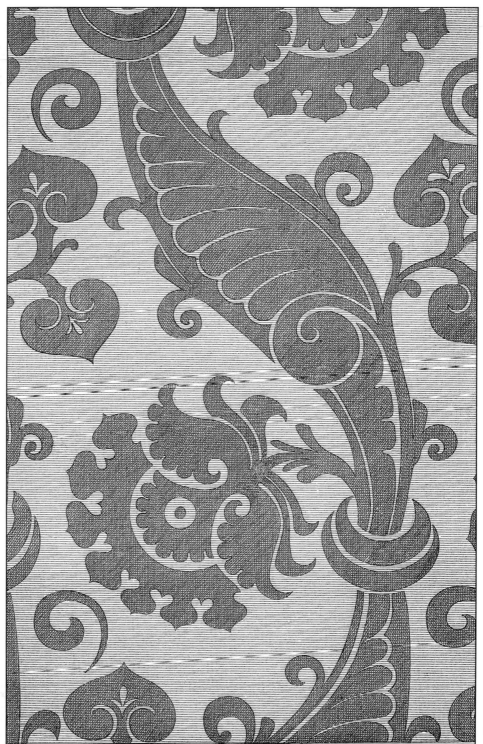

81

Venetian fabric,
12th century.
Étoffe vénitienne,
XIIᵉ siècle.
Venezianischer Stoff,
XII. Jahrhundert.
Венецианская ткань,
12 век.

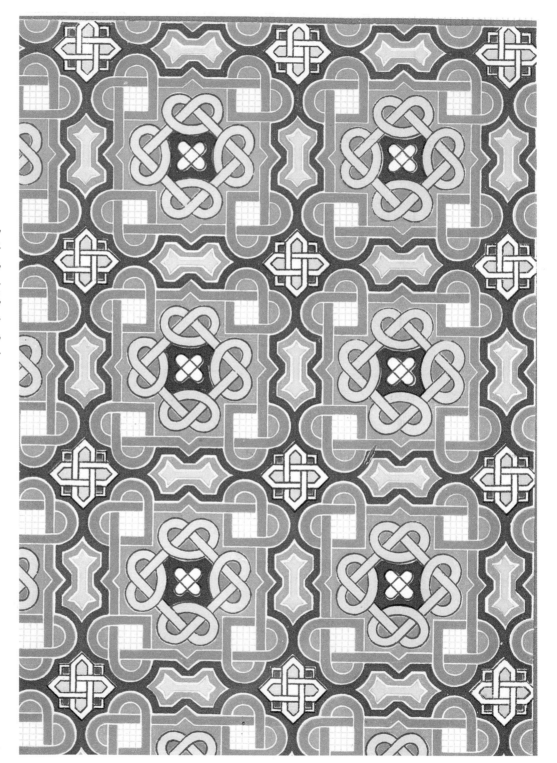

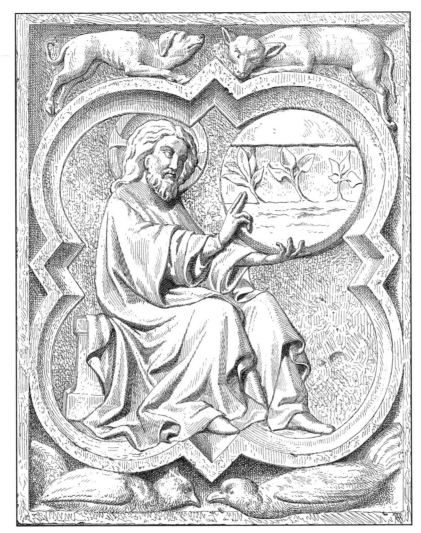

83-1

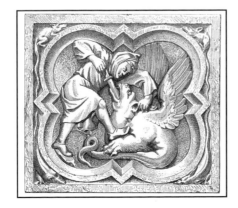

Bas-reliefs, Rouen Cathedral, 14th century.
Bas-reliefs à la cathédrale de Rouen, XIVᵉ siècle.
Französische Schule, Flachreliefs an der
Kathedrale von Rouen, XIV. Jahrhundert.
Барельеф, Руанский собор, 14 век.

83-2

83

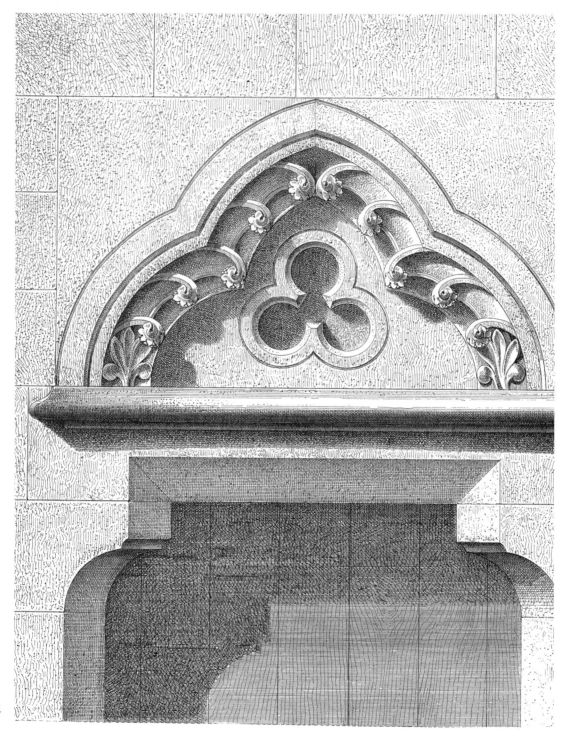

Top of door,
Rouen Cathedral,
13th century.
Couronnement de
porte à la cathédra-
le de Rouen,
XIIIᵉ siècle.
Französische
Schule: Türkrone
an der Kathedrale
von Rouen,
XIII. Jahrhundert.
Французская
школа. Верхняя
часть двери,
Руанский собор,
13 век.

84

Foliated patterns,
Rouen and Sens
Cathedrals,
12th century.
Rinceaux sculptés,
cathédrales de
Rouen et Sens,
XII^e siècle.
Französische
Schule.
Rundornamente
aus dem Stein
gemeißelt,
Kathedralen von
Rouen und Sens,
XII. Jahrhundert.
Лиственный
орнамент,
Руанский собор
и кафедральный
собор в Сансе,
12 век.

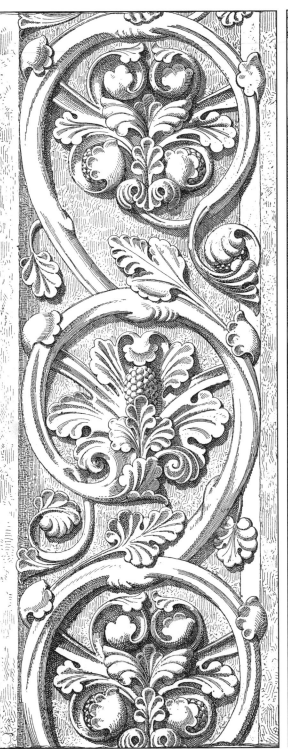

85-1

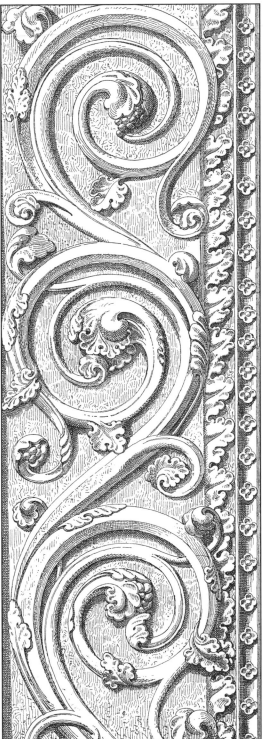

85-2

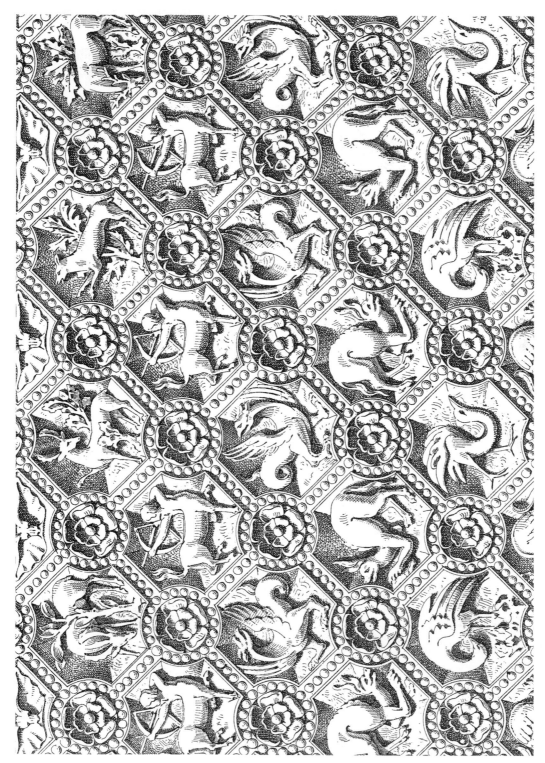

86; 87:
Monumental
decoration, France,
14th century.
Décoration
monumentale,
France, XIV^e siècle.
Monumentale
Dekoration,
Frankreich,
XIV. Jahrhundert.
массивное
украшение,
Франция, 14 век.

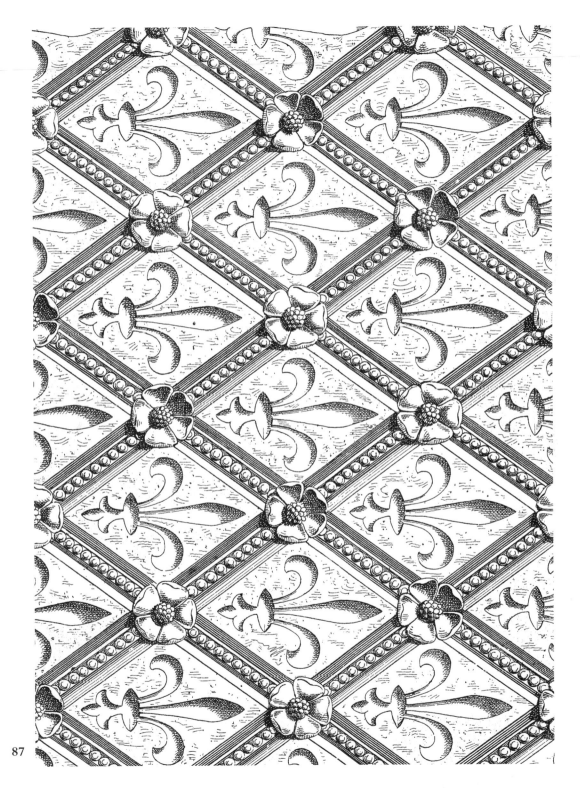

87

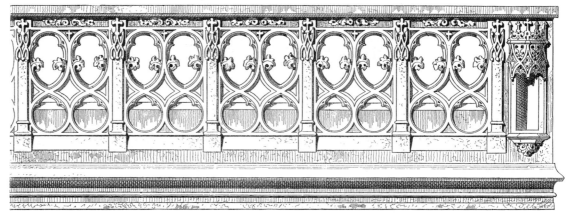

88-1

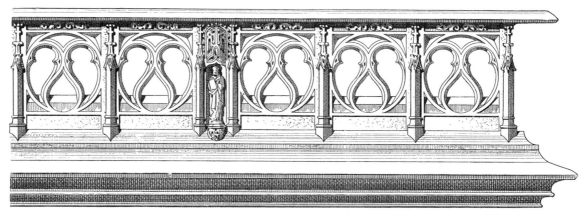

88-2

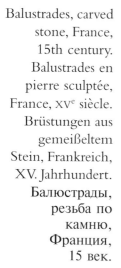

Balustrades, carved stone, France, 15th century. Balustrades en pierre sculptée, France, XVᵉ siècle. Brüstungen aus gemeißeltem Stein, Frankreich, XV. Jahrhundert. Балюстрады, резьба по камню, Франция, 15 век.

88-3

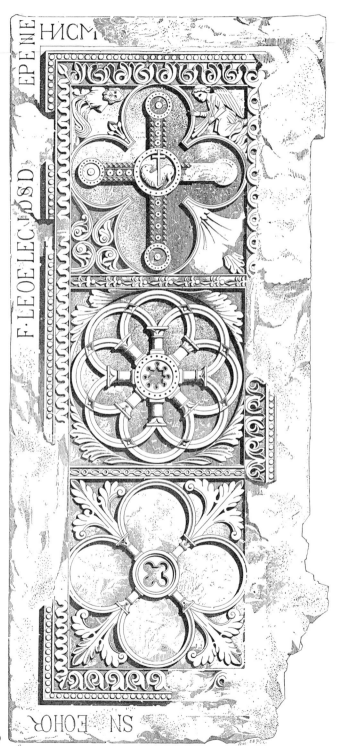

Tomb of Peter the Venerable,
France, 12th century.
Tombe de Pierre le Vénérable,
France, XIIᵉ siècle.
Grab von Peter des
Ehrwürdigen, Frankreich,
XII Jahrhundert.
Гробница преподобного
Петра, Франция, 12 век.

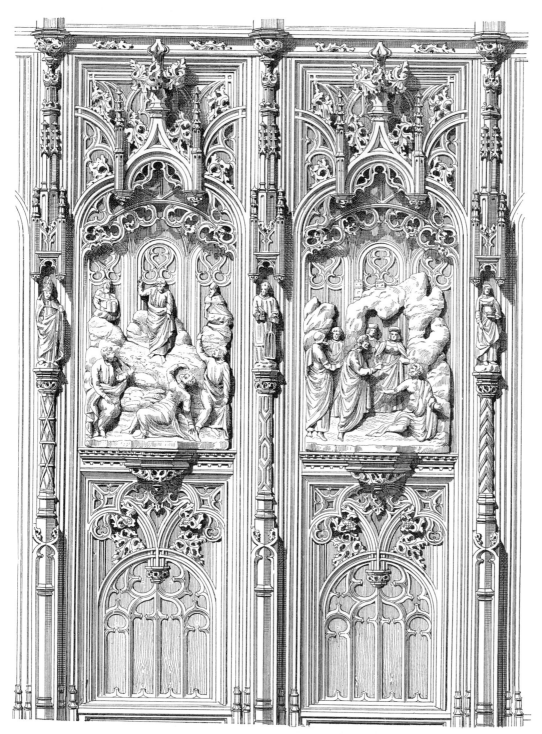

Decorative
woodwork, Flemish
School, 15th century.
Boiserie sculptée,
École flamande,
XVᵉ siècle.
Flämische Schule.
Holztäfelung mit
Reliefschnitzereien,
XV. Jahrhundert.
Резная деревянная
панель,
Фламандская
школа, 15 век.

Stairs, carved stone, France,
15th century.
Escalier sculpté en pierre,
France, XVᵉ siècle.
Treppe, aus Stein gehauen,
Frankreich, XV. Jahrhundert.
Лестница, резьба по
камню, Франция, 15 век.

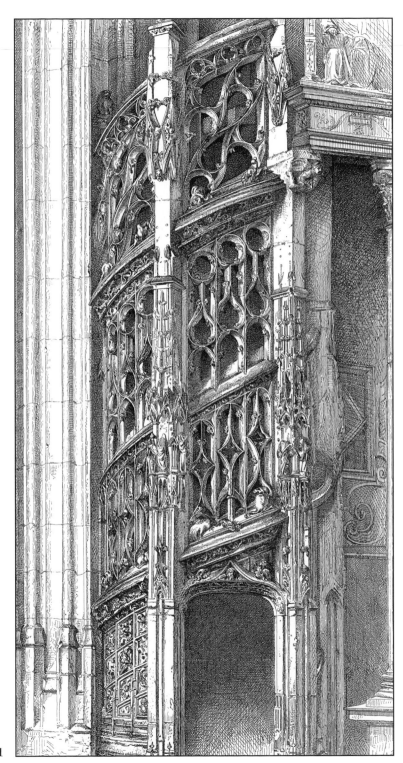

91

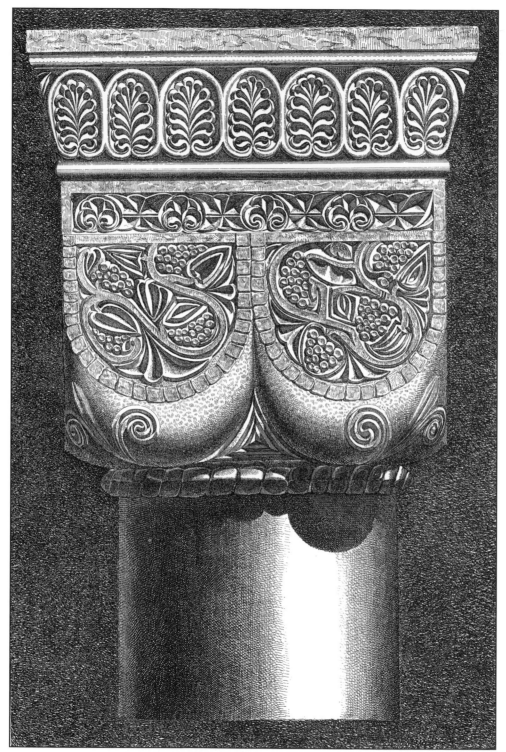

Capital, Rhenish School,
10th century.
Chapiteau, École
rhénane, Xᵉ siècle.
Kapitell, Rheinische
Schule, X. Jahrhundert.
Капитель, Рейнская
школа, 10 век.

93-1

93-2

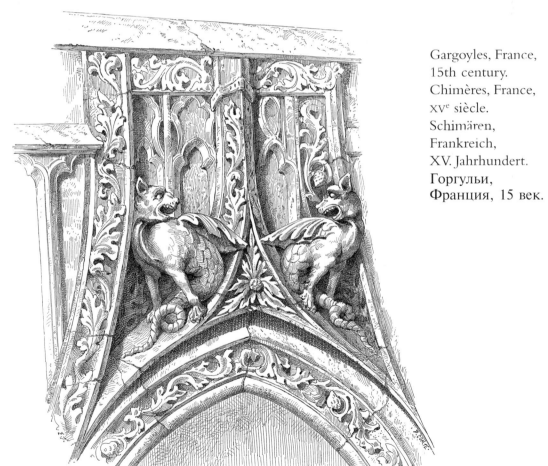

Gargoyles, France,
15th century.
Chimères, France,
XVᵉ siècle.
Schimären,
Frankreich,
XV. Jahrhundert.
Горгульи,
Франция, 15 век.

93-3

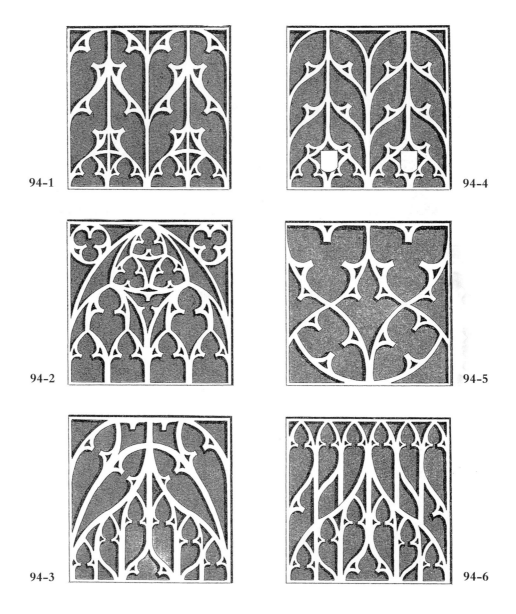

94-1

94-4

94-2

94-5

94-3

94-6

94; 95:
Gothic sculpted ornaments, Nuremberg, 15th century.
Ornements sculptés gothiques, Nuremberg, XVᵉ siècle.
Gotische geschnitzte Verzierungen, Nürnberg, XV. Jahrhundert.
Готические скульптурные орнаменты, Нюрнберг, 15 век.

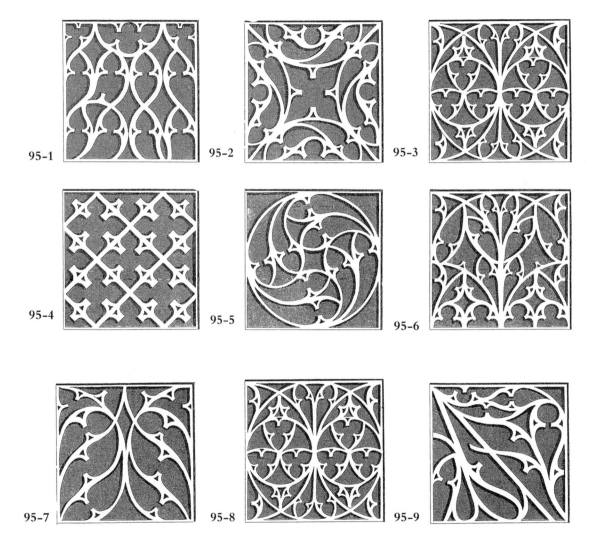

95-1

95-2

95-3

95-4

95-5

95-6

95-7

95-8

95-9

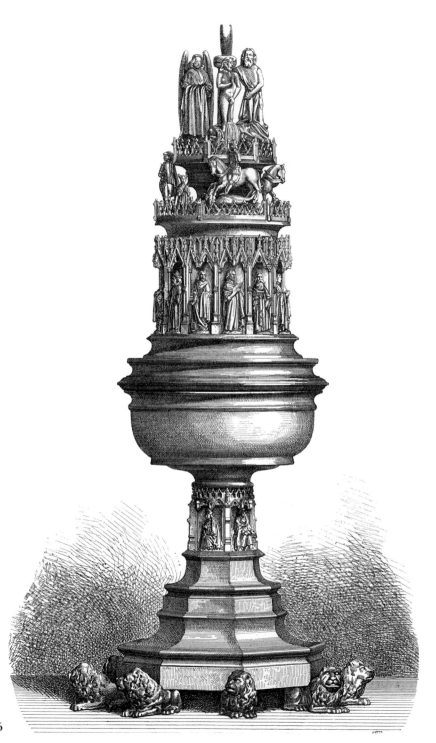

Baptismel fonts, Flemish
School, 15th century.
Fonts baptismaux, École
flamande, XVᵉ siècle.
Neues Affenspiel, Frankreich,
19. Jahrhundert.
Купель для крещения,
Фламандская школа, 15 век.

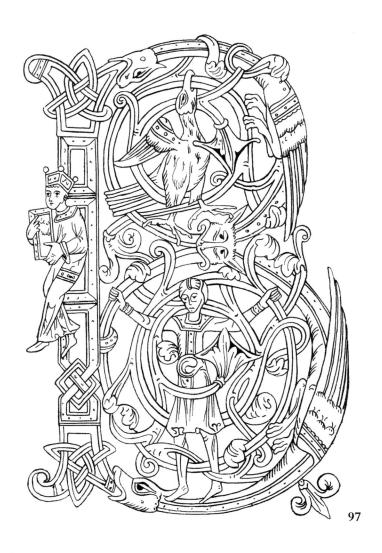

97

Initial, Flemish School, 12th century.
Lettre ornée, École flamande, XIIᵉ siècle.
Flämische Schule, Briefschmuck, XII. Jahrhundert.
Заглавная буква, Фламандская школа, 12 век.

98-1

98-2

99-1

99-2

99-3

99-4

98-101:
Initials, German School, 11th century.
Majuscules ornées, École allemande, XIᵉ siècle.
Deutsche Schule: Geschmückte Großbuchstaben, XI. Jahrhundert.
Заглавные буквы, Немецкая школа, 11 век.

99

100-1

100-2

101-1

101-2

101-3

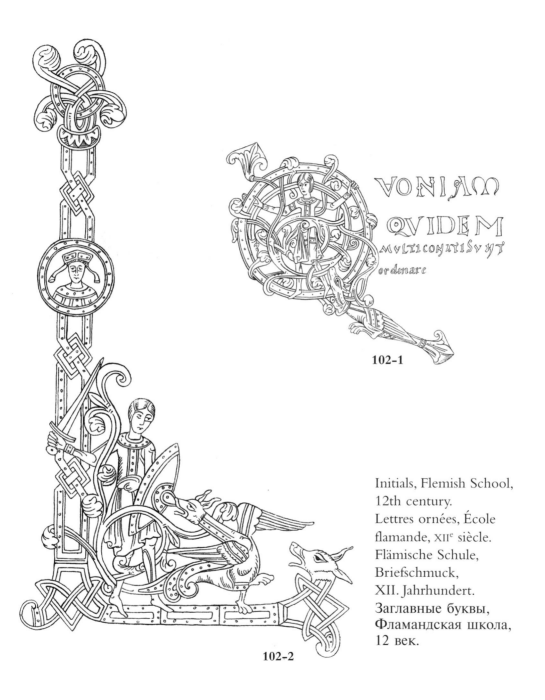

VONIAM
QVIDEM
MVLTICONATISVNT
ordinare

102-1

102-2

Initials, Flemish School,
12th century.
Lettres ornées, École
flamande, XIIᵉ siècle.
Flämische Schule,
Briefschmuck,
XII. Jahrhundert.
Заглавные буквы,
Фламандская школа,
12 век.

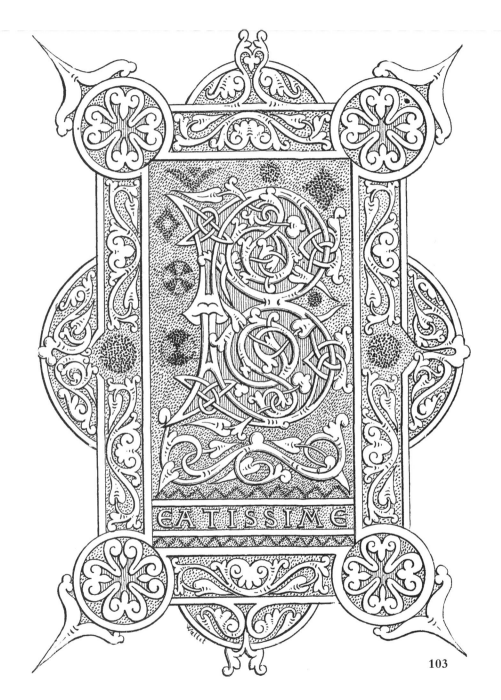

Illuminated initials,
Byzantine School,
12th century.
Lettre enluminée, École
byzantine,
XIIᵉ siècle.
Briefschmuck,
Byzantinische Schule,
XII. Jahrhundert.
Обрамленные буквы,
Византийская школа,
12 век.

103

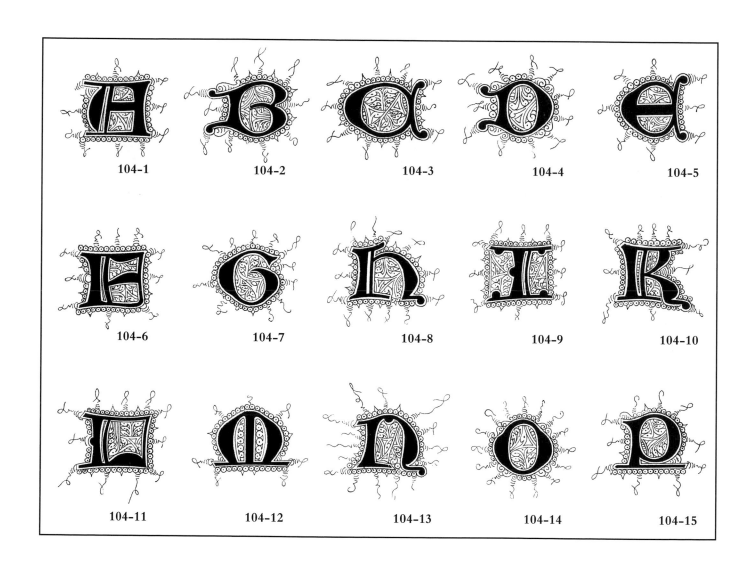

104-1 104-2 104-3 104-4 104-5

104-6 104-7 104-8 104-9 104-10

104-11 104-12 104-13 104-14 104-15

104; 105:
Uncial alphabet, German School, 14th century.
Alphabet oncial, École allemande, XIVe siècle.
Deutsche Schule:Verziertes Alphabet, XIV. Jahrhundert.
Унциальный алфавит, Немецкая школа, 14 век.

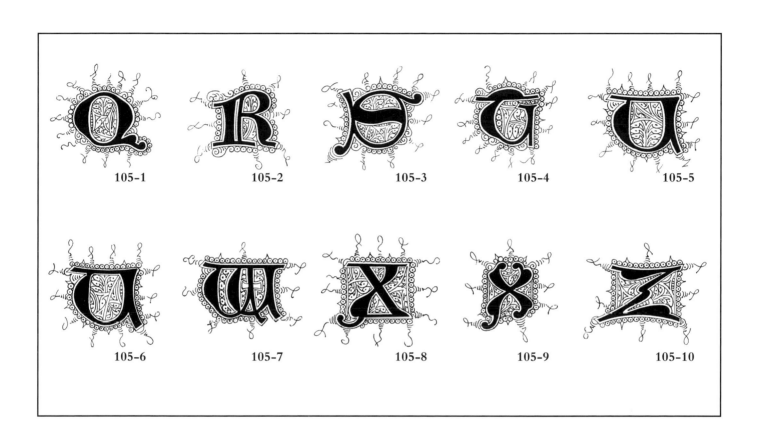

105-1 105-2 105-3 105-4 105-5

105-6 105-7 105-8 105-9 105-10

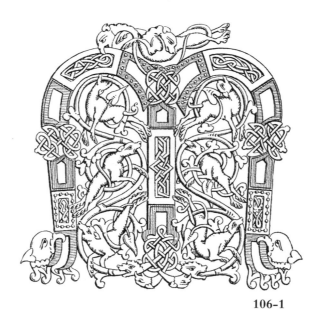

106-1

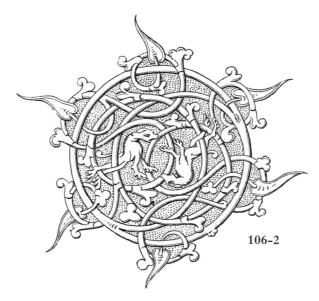

106-2

Illuminated initials, Byzantine School, 12th century.
Lettres enluminées, École byzantine, XIIᵉ siècle.
Briefschmuck, Byzantinische Schule, XII. Jahrhundert.
Обрамленные заглавные буквы, Византийская школа, 12 век.

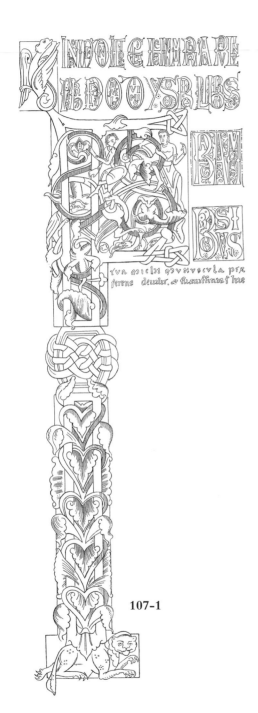

107-1

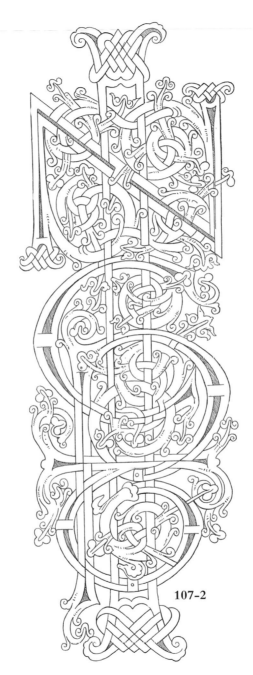

107-2

Adorned and
intertwined initials,
France, 12th century.
Lettres ornées et
entrelacées, France,
XIIᵉ siècle.
Briefschmuck,
Frankreich,
XII. Jahrhundert
Декоративные и
переплетающиеся
буквы, Франция,
12 век.

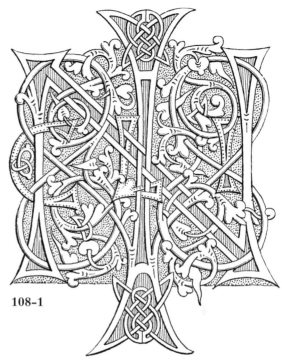

108–1

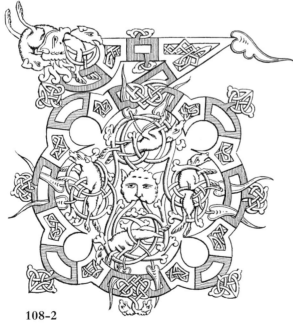

108–2

108; 109:
Illuminated initials, Byzantine School,
12th century.
Lettres enluminées, École byzantine,
XIIᵉ siècle.
Briefschmuck, Byzantinische Schule,
XII. Jahrhundert.
Обрамленные заглавные буквы,
Византийская школа, 12 век.

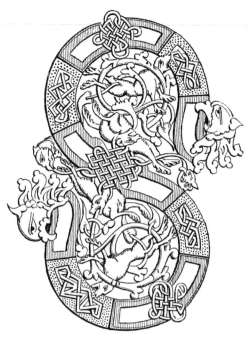

109-1

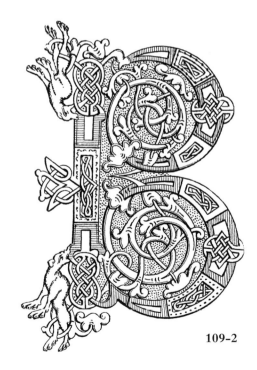

109-2

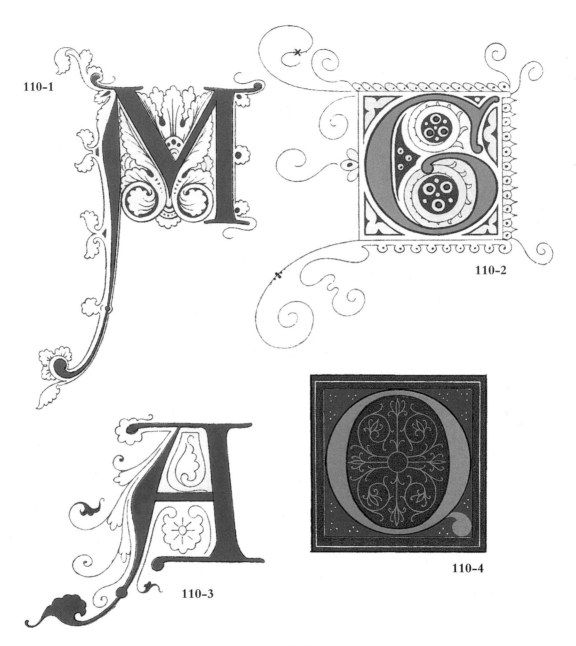

110–112:
Illuminated initials, France, 12th, 14th and 15th centuries.
Lettrines enluminées, France, XIIᵉ, XIVᵉ et XVᵉ siècles.
Briefschmuck, Anfangsbuchstaben, Frankreich, XII., XIV. und XV. Jahrhundert.
Обрамленные буквы, Франция, 12-й, 14 и 15 века.

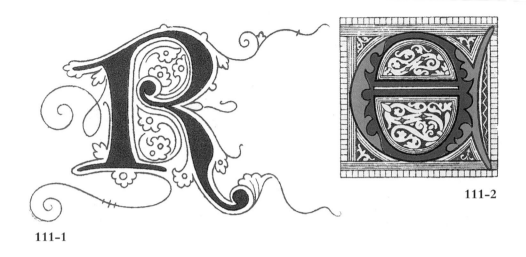

111–1

111–2

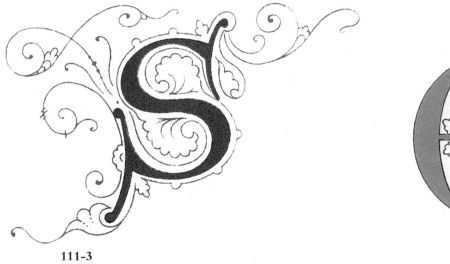

111–3

111–4

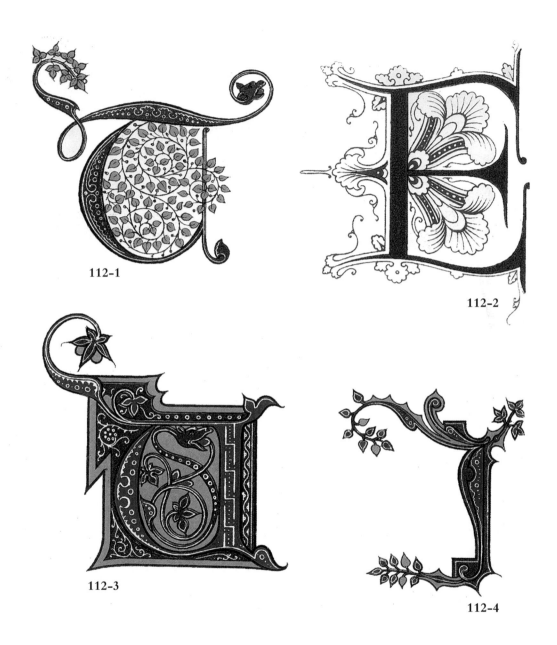

112-1

112-2

112-3

112-4

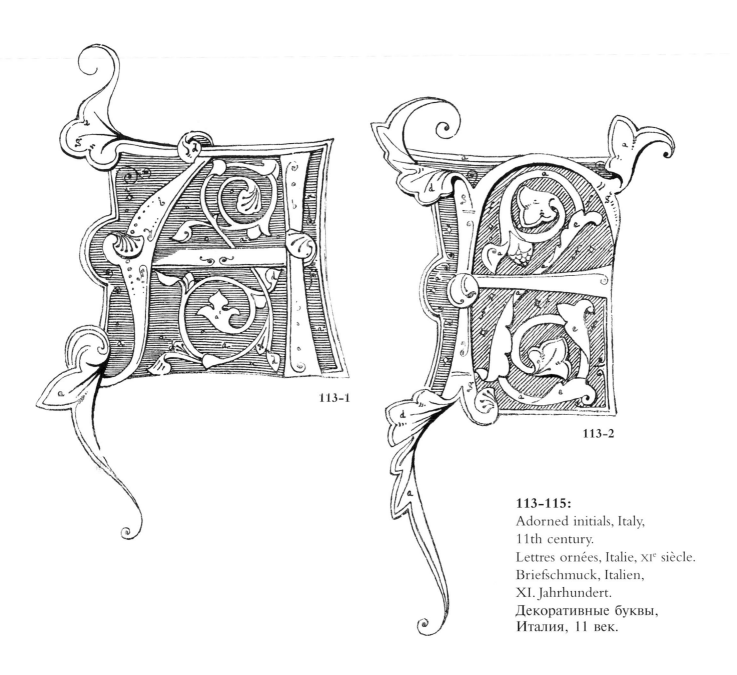

113-1

113-2

113–115:
Adorned initials, Italy,
11th century.
Lettres ornées, Italie, XIᵉ siècle.
Briefschmuck, Italien,
XI. Jahrhundert.
Декоративные буквы,
Италия, 11 век.

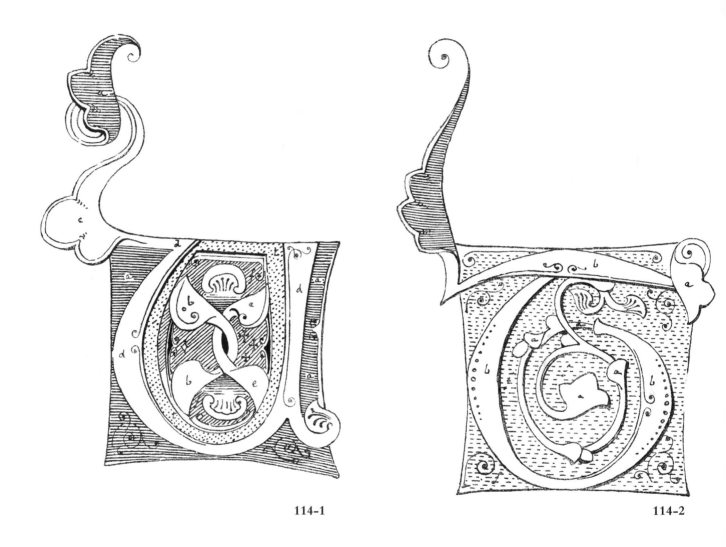

114-1

114-2

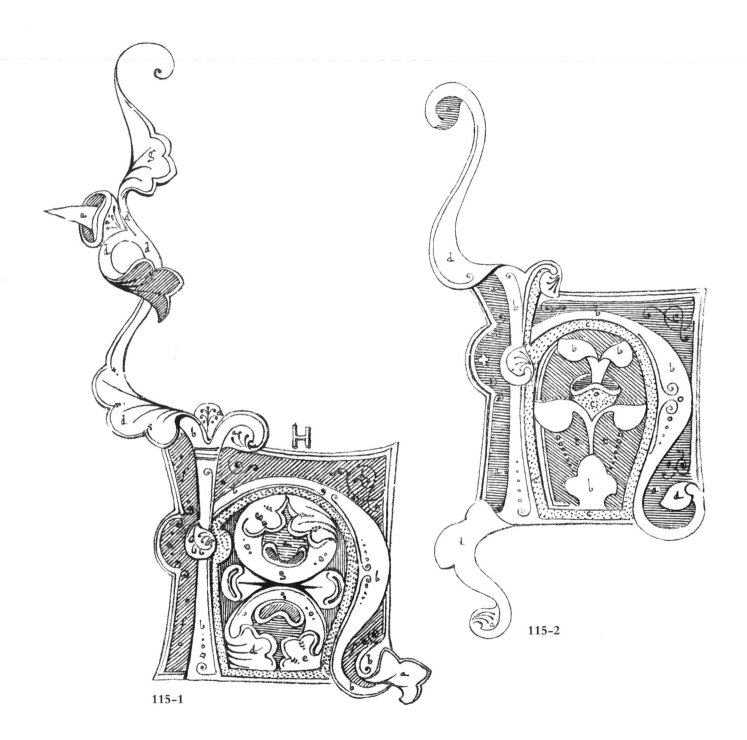

115-1

115-2

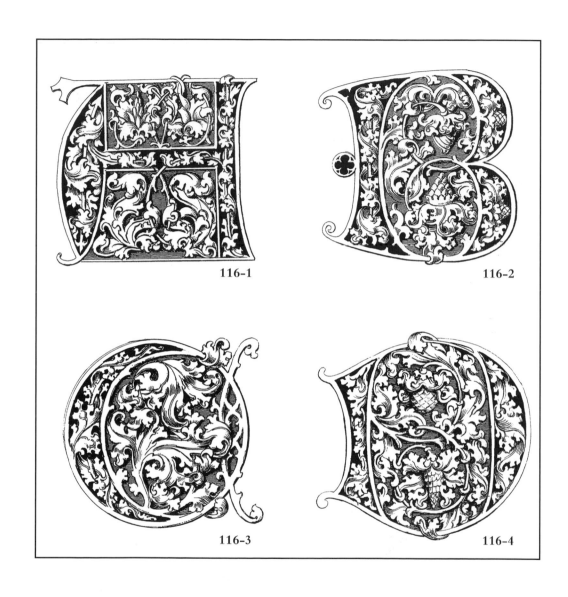

116-1 116-2

116-3 116-4

116–118:
Gothic initials.
Lettres gothiques.
Gotische Buchstaben.
Буквы в стиле готика.

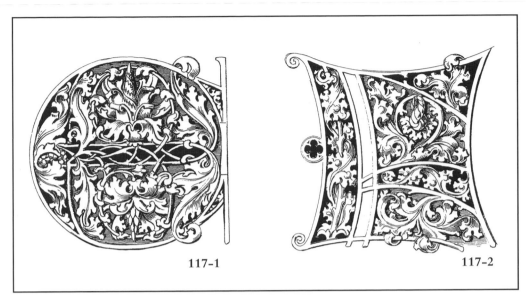

117-1

117-2

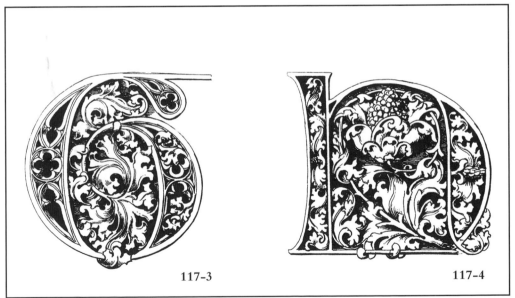

117-3

117-4

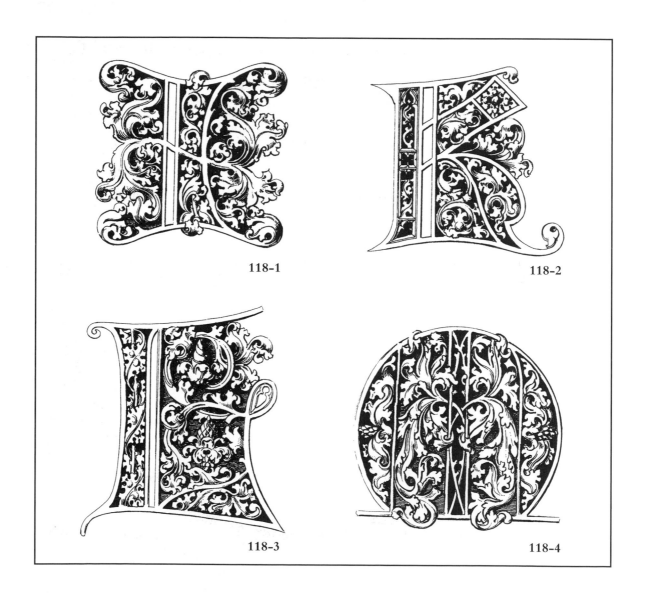

118-1

118-2

118-3

118-4

119; 120:
Italian calligraphy, 15th century.
Calligraphie italienne, XVᵉ siècle.
Italienische Kalligraphie
XV. Jahrhundert.
Итальянская каллиграфия,
15 век.

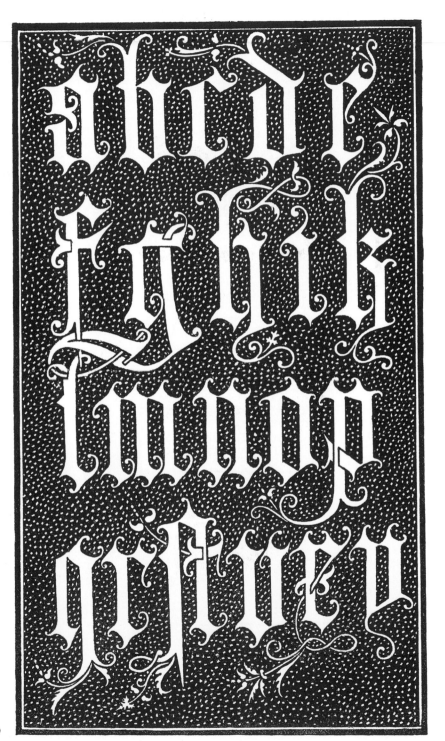

119

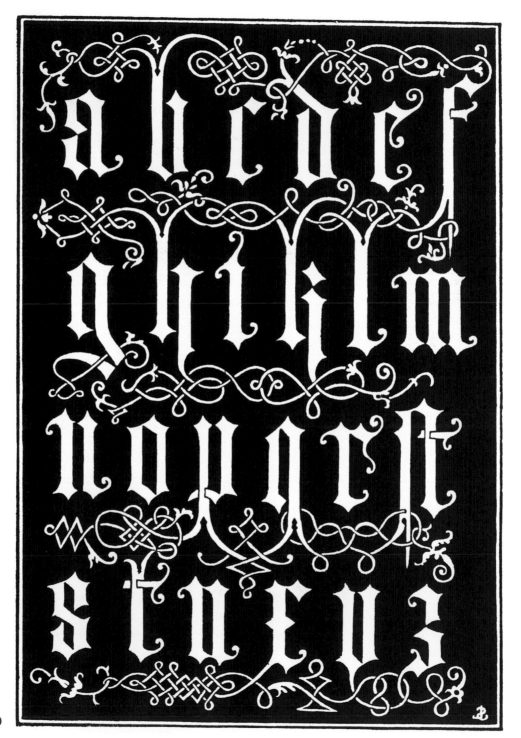

120

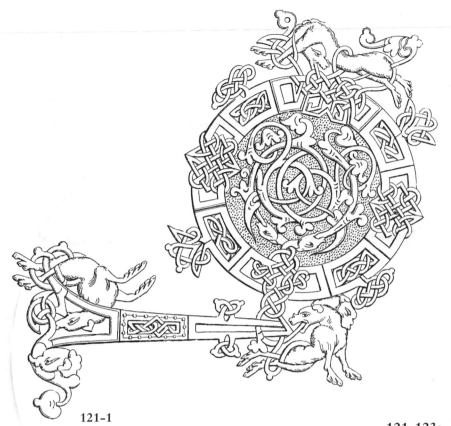

121-1

121-2

121-123:
Illuminated initials,
Byzantine School,
12th century.
Lettres enluminées,
École byzantine,
XII^e siècle.
Byzantinische Schule.
Briefschmuck,
Buchstaben der
Miniaturmalerei,
XII. Jahrhundert.
Обрамленные
буквы,
Византийская
школа, 12 век.

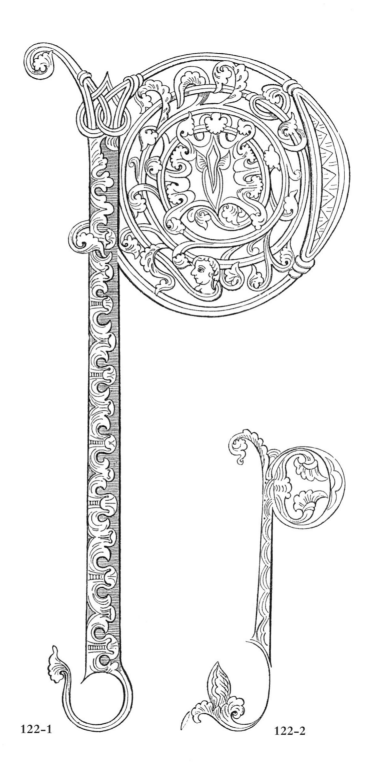

122-1 122-2

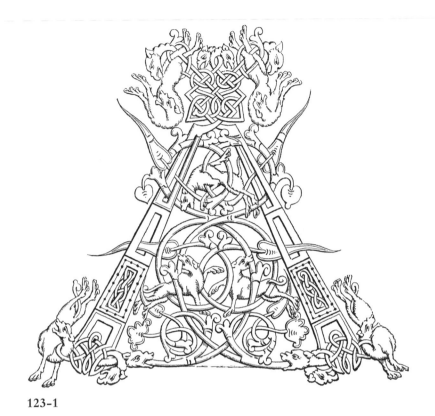

123-1

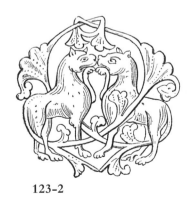

123-2

Borders • Bordures Borduren • Бордюры

L'Aventurine

Free CD-Rom for PC/Mac high resolution

Renaissance Ornaments • Ornements Renaissance • Renaissance Ornamente Орнаменты Ренессанса

L'Aventurine

Free CD-Rom for PC/Mac high resolution

Arabic Ornament • Ornement arabe Ornamentación árabe • Arabische Ornamente

L'Aventurine

Free CD-Rom for PC/Mac high resolution

Arabesques • Arabesken Арабески

L'Aventurine

Free CD-Rom for PC/Mac high resolution

Costumes • Kostüme КОСТЮМЫ

L'Aventurine

Free CD-Rom for PC/Mac high resolution

Fantastic Ornaments • Ornements fantastiques • Fantastische Ornamente Фантастический Орнамент

L'Aventurine

Free CD-Rom for PC/Mac high resolution

Japanese Ornament • Ornement japonais • Japanische Ornamente Японский Орнамент

L'Aventurine

Free CD-Rom for PC/Mac high resolution

Silhouettes • Schattenbilder Силуэты

L'Aventurine

Free CD-Rom for PC/Mac high resolution

Floral Ornament
Ornement Floral
Blumen Ornamente
Ornamentación Floral
Цветочный Орнамент

L'Aventurine

Free CD-Rom for PC/Mac
high resolution

Art Nouveau Ornament
Ornement Art nouveau
Jugendstil Ornamente
Ornamentación Arte nuevo
Арт Нуво Орнаменты

L'Aventurine

Free CD-Rom for PC/Mac
high resolution

Ironwork • Fer forgé
Schmiedeeisen • Hierro forjado
Изделия из металла

L'Aventurine

Free CD-Rom for PC/Mac
high resolution

Typographic Decoration
Décor typographique
Typographische Muster
Decoración tipográfica
Типографский декор

L'Aventurine

Free CD-Rom for PC/Mac
high resolution

Alphabets
Alphabete
Alfabetos
Алфавиты

L'Aventurine

Free CD-Rom for PC/Mac
high resolution

Egyptian Ornament
Ornement égyptien
Ägyptische Ornamente
Ornamentación egipcia
Егилетский орнамент

L'Aventurine

Furniture
Mobilier
Mobiliar
Mobiliario
Мебель

L'Aventurine

Achevé d'imprimer en Slovaquie
en septembre 2007
Dépôt légal 3e trimestre 2007